The Art of Disability

A handbook about Disability Representation in Media

By David Proud

Copyright © 2016 David Proud

All rights reserved, including the right to reproduce this book, or portions thereof in any form. No part of this text may be reproduced, transmitted, downloaded, decompiled, reverse engineered, or stored, in any form or introduced into any information storage and retrieval system, in any form or by any means, whether electronic or mechanical without the express written permission of the author.

ISBN: 978-1-326-86680-8

PublishNation
www.publishnation.co.uk

Dedicated to my beautiful wife Amy, without you this book would still just be an ambition, thank you for helping me bring it to life. xxx

Contents

1. Disability and Diversity Page 1
2. Presenting and the Corporate Sector Page 15
3. Language and Tone Page 20
4. Writers Page 30
5. Commissioners and Controllers Page 37
6. Executive Producers/Producers Page 43
7. Casting Directors/Agents Page 57
8. Directors, Assistant Directors, DOP's Page 67
9. New Actors Page 81
10. New Film makers Page 119
11. Experienced Actors Page 125
12. Summary Page 140
13. With thanks… Page 143
14. About me Page 145
15. Appendix A Page 147
16. Appendix B Page 149

"Man (or woman) invented the wheel in 3500 BC but didn't invent tarmac until 1901, until then wheels were trying to negotiate mud, grass, cobbles, and gravel. The world was not accessible to the wheel for thousands of years, but we didn't reinvent the wheel. We understood that it was perfect as it was, but we could adapt the environment around it to maximise its potential. Disability has empathy with the wheel having to wait thousands of years for humanity to adapt to it. At the moment, it feels like society looks to change disabled people, to reinvent the wheel, when they should be focussed on adapting the world around it..."

Disability and Diversity

What is disability? The dictionary definition is;

"a physical or mental condition that limits a person's movements, senses, or activities."

All of us have a part of ourselves that is not normal, if we can ever understand what normal is, we all have body hang ups and would change something about ourselves if we could. Nobody is perfect, none of us, it's a myth. In our daily lives when looking at people we may think on the surface they look 'perfect' and 'normal', but in truth none of us are. So even if you have never associated yourself with being disabled you probably are in some small way, if not then by default you are normal, and normal just does not exist.

There is a diversity of disability in the world, from the smallest little condition to some more complex disabilities. Disability is a very complex minority, even when you are disabled it is impossible to fully understand every disability and the problems people are trying to overcome. If you are trying to learn about disability you are embarking on a tough challenge. No two people are the same, no two disabilities are the same, how a disability affects a human body is different for each person.

It's human nature to crave order, that's why we love abstract paintings, in our minds we like to make sense of subject matter and order it so that we can understand it. How do we make sense of disability and put it into a form that can be useful? I see all disabilities in two categories, acquired disability, and

those born with a condition, we will revisit this idea throughout this book. As a person born with a disability I have known nothing else, my disability has been with me my whole life and I had to find ways to adapt and to embrace my difference. That doesn't mean I am immune to the problems it creates, I still have to deal with it every day, I have just developed very strong coping mechanisms. It is ingrained into my identity and always has been.

When someone acquires a disability they are going through a massive life altering process, a massive alteration of identity. Overnight their body has changed and they must learn to accept that and move on, this process takes a long time. The greatest example of this is someone who suffers a spinal injury. When you lose the ability of a body part, or a bodily function it leads to psychological issues you must deal with. In some ways the psychological trauma takes longer to repair than any physical injury, because a body can be repaired quicker than an identity.

This is the easiest way to break disability down for people working in media. Have they acquired their disability or were they born with it? It can make a very big difference in the mind-set of the character you are portraying, or writing. It can also impact the way in which a disabled artist/person might engage in conversation with you, which we will cover in the section on Language and tone.

There is a third category worth considering and this is for hidden disabilities. These can be a much bigger burden to live with and can have daily life altering consequences. When I approach a door people see my wheelchair and open the door for me, they know the help I might need. For people that have a hidden disability there is a need to explain why they struggle to

do something, it isn't as obvious so help is not as forthcoming. Social exclusion can be more likely as there is a lack of understanding about how that hidden disability effects people's ability to participate in everyday life.

The public have a fear and fascination with criminals, which is why we see so many crime shows, but people don't want to be the victim of a crime. In a similar way there is a fear and fascination with disability. People don't like to be reminded about the fragile nature of life and how circumstances might remove body function, but at the same time they love to see it, to understand it, and to learn.

Before we look at ways in which we can improve disability representation in media let's take a moment to really understand this community of 11 million people in the UK. What is life like for a disabled person living in today's world? We can't represent what we do not understand.

Obviously I have my own view on this but I knew someone who would have a more comprehensive understanding as they are uniquely placed to consider all factors. I have known entrepreneur Martyn Sibley for many years now and although we work in different industries we share similar goals. Martyn has a Degree in Economics and a Masters in Marketing, he founded and runs Disability Horizons on online network that has many different offshoots and bespoke projects, he is truly an amazing entrepreneur. What I like about Martyn, amongst other things, is that while others might grab a pitch fork and placard, Martyn is talking to people to offer a solution to problems. He doesn't dwell on what's wrong, he is focussed on how to make it right.

I asked Martyn to describe what challenges disabled people were facing in today's tough economic climate.

On the one hand we have seen the progress in disability rights the past couple of decades. Many more disabled people access mainstream education, work, leisure, travel, have relationships and families. Plus much much more.

On the other hand the well documented global financial crisis has hit everyone, but particularly disabled people. As governments make cuts, we are seeing the vulnerable being hit the hardest.

There is less support for health care, independent living (equipment, care, and adaption's), mental health and so on. The stupidity is that when you cut the foundations people need to function, they lose their actual and potential value in society. Plus they will ultimately rely more on governmental help.

Conversely by investing in people's needs; they are happier, healthier, and more productive.

The above looks at disability from an economic perspective. It's obvious that beyond the costs to society, disabled people are suffering emotionally too. Nobody wants to rely on outside help or feel victimised. They certainly want to be valued more. Therefore we can conclude the biggest issue is of image and attitude.

Once society sees disabled people as equal citizens, cutting their human rights and needs will not be accepted any longer.

It's interesting that Martyn mentions human rights, have you ever read the articles of the Human Rights Act? It's one of those things you think you know, but reading them gives you a better clarity. You may be aware that it covers discrimination but might be surprised that one article is specifically for *Freedom of Expression*s, is that basic human right being met

by UK broadcasters? One could argue that this elevates the discussion from one of diversity to one of basic equality. We live in a world where language matters and the word *"diversity"* seems to dilute the issue, let's be clear, we are talking about basic human rights, we are talking about equality. It is then easier to understand why feelings on the matter do lead to very emotional responses.

Martyn is listing image and attitude as a big issue. At the moment there is a scheme called "Access to Work" and we will touch upon it in more detail later but sadly it is suffering from the recent government cuts. It exists to help finance any reasonable adjustment that needs to be made in order to allow a disabled person to access work. I wanted to know from Martyn what impact the cuts are having on the lives of disabled people.

The cuts in Access to Work are the most hypocritical. Our government seeks to encourage work and limit reliance on benefits. This is flawed for many reasons including the fact not everybody is able to work. Moreover by cutting the financial support to work, it puts people further from the job market.

Yes, care/transport/technology for disabled people costs money. However, when out of work people can't afford food and housing. Nor can they contribute to the economic reliance on consumer spending.

By enabling disabled people to work, can you guess what you get? Exactly - better health, happiness, productivity AND spending.

Instead of a one dimensional view of disability meaning 'burden' or 'scrounger', society needs to understand the win:win of investment in overcoming the barriers faced for many people in our world.

You can see why I admire Martyn's articulate viewpoint. So how can media play a role in helping challenge any negative images and attitudes?

We've looked at the flaws of government policy, particularly in accessing work, for disabled people. The truth is that via our democratic processes, we choose these governments. Therefore it is the attitude of everyone that needs to change on disability. How does this happen though? The media!

From the news, to reality TV shows, to soaps, to films (and beyond); the representation of disability is at best non-existent. At worst it is the extremities of 'brave hero' and 'tragic sob story'. Don't forget benefit scrounger too.

Only recently I worked on a story about a mother who killed her three disabled children. Just to get the news to describe their disability was a mission. The rest of the messaging sent signals to society that are beyond belief.

Nonetheless the media has improved. We do see more positive news stories, disabled characters, and the covering of disability topics. Let's hope this increases and improves going forward.

Interesting points on how disabled people are represented, it isn't just about numbers. My final question to Martyn was to name a representation of disability he could most relate too and sadly he couldn't name one.

Now we have a slight introduction into disability in society how is disability being represented in media?

In 2014 I was invited to attend a round table on diversity at BAFTA, sadly I was unable to attend but I received the minutes from the meeting and I was delighted that it was

attended by my friend Justin, a director I often work with. As I read the notes something that Justin said in the minutes hit me like a bolt out of the blue, he stated that in order to correctly represent disabled people there would have to be over 44,000 disabled people working in the media industry, I stopped reading, surely this figure is incorrect? I was stunned by its sheer magnitude, 44,000 disabled people. I did the mathematics and it's a surprisingly simple figure to calculate, take the 11 million disabled people in the UK and work out the percentage compared to the UK population. Then apply that percentage to the total number of people working in media and we arrive at 44,000 give or take a few, depending on which census you are working on. Staggering when you look at the issue in simple numbers, and it shows that we have some work to do. As a disabled artist I was in shock, Justin's point has just highlighted how far we have to go, all other targets for diversity are now redundant. Surely anything under 44,000 means we have failed, haven't we?

Diversity seems like an ideology that we all agree is valid, we all want, but have no idea how to achieve it. So why try to readdress the balance? Is disability diversity really that important? Surely to tackle such a large issue the benefits would need to be worth the effort, the juice worth the squeeze. Let's consider it:

By not representing the disabled community you are alienating 11 million potential viewers. If you represent them, they will watch! It is worth considering that those 11 million people have families and friends who will also feel a closer connection to disability, so in fact that number could double, easily. In fact a UK government statistic has estimated that the "Purple Pound" (The name given to spending from the disabled

community), is worth £212 Billion in the UK. It is a figure created when looking at the annual combined spending power over every household in the UK with at least one disabled resident. Let's say it again, the purple pound is worth **£212 Billion.** This is a readily available government figure. For those thinking that disability is a niche, it's a niche worth engaging.

An argument could also be made that even if you were to view disability as a niche, if you look globally, it becomes a macro niche. Disability percentages fluctuate around the globe but seem to all be in the region of 20% per population. With that in mind we can argue that there are likely to be 1.48 billion disabled people in the world. Can you call 1.48 billion a minority? It can also be argued that with an ageing population this is a minority that is rapidly growing. A film with disability themes potentially has a very big market. This has to be one of the biggest arguments for greater representation, in a market that is seeing huge growth in the UK in terms of production, but instability in box office and ancillary markets we should not be ignoring a minority audience of 11 million people, or a global one of 1.48 billion.

The UK disabled Film and TV acting industry is like a broken factory machine, it spits out a handful of guest episodes and maybe one regular job a year, but for most of the year it lays dormant. Theatre is a little better and it's refreshing to see the rise of Art groups, festivals and events. The problem with the disabled acting industry is that there is no disabled acting industry, there is not a clear vocational path, enough employment opportunity or any sign of sustainability. We have around fifty male artists and fifty female artists that have professional experience in TV and Film. Around ten percent of

those have very strong, long term experience. These few seem to have weathered the diversity storm for years. What can we learn from their longevity? Most schemes run by broadcasters look to 'find new talent' which we need to be doing all year round, however, at the moment this compounds the problem. With no sustainability, how are the artists of today going to secure continued work to still be here in five years' time? We have had over a decade of many short run schemes looking to find new talent and this has not created the impact that it set out to achieve, the cumulative effect of these schemes is a shallow pool of talent, with sporadic experience. This does not come close to creating a tidal wave of change. This issue will not be solved with a scheme, as with any equality issue, this will only be solved with a complete understanding of the situation and a fundamental change in how we think about disability. Moving from seeing weakness, to seeing strength, from unemployable to employable, from worthless to valuable. Let's repeat that as it's critically important, in order to move forward we need a fundamental change in how we think about disability.

You might think that this is a bleak picture, and it must be said as a disabled artist in the UK at times it does feel bleak, however let's not dwell on the negative, where there is a problem there is always a solution. Like any change it takes time, effort, and hard work. Many industry members say about potential barriers to working with disabled artists, so here is a small book trying to address some of those concerns. The aim of this book is that disabled artists and all industry members read it, and it empowers the artist and reassures the producer or director who is thinking of diversity. As I engaged industry professionals to give viewpoints, this book took me on an

interesting journey, and I hope you find that journey interesting too.

It is recommended that you read all the sections no matter what your role is within a production. Films and TV shows are a team game, and it is good to understand the differences with working with disabled artists at every step of production. Reading this book cover to cover, is a great way to support diversity through understanding.

This book may be slightly bias to physical disability as that is my experience, but the aim is to kick start a tidal wave of books about disability, and guides and textbooks. It's an art and it deserves its own methodology and study.

Martyn has given us a great insight into the lives of disabled people in the UK, both in terms of economic status and societies attitudes. Before we move to the next chapter to be balanced I wanted to see the viewpoint from the Governments perspective.

Ed Vaisey, Minister of State for Culture and the Digital Economy[1] is chair of a BFI roundtable on diversity. I have to admit that I am sometimes guilty of scepticism when I hear a politician is attending an event but I have to say I have been very impressed with Ed Vaisey at the BFI roundtable events. He demonstrates a clear understanding of the issues, and is passionate about eradicating the issues, he was also the first person to agree to contribute to this book, I was delighted when he sent me this very prompt and nice response.

I asked Ed Vaisey how important is correct representation of disabled people in media?

For me, it is very important. The Government is committed to promoting equality for disabled people and to tackling discrimination wherever it arises. A key word in your question though is the word "correct" and in terms of equality it is imperative that all representation of disabled people in the media is conducted with the sensitivity and respect that we would expect to be afforded to anyone.

So, it isn't just about correct representation, it's about discrimination and equality, certainly gives the subject a bigger sense of importance as mentioned before. I was keen to gauge what effect correct representation has on UK Culture?

For the creative industries it is important that that creativity reflects the diversity that makes up our society, as Hamlet says of the players in Shakespeare's play, "They are the abstract and brief chronicle of the time.........".
We are committed to seeing a better balance of diversity across all sectors and at all levels of seniority. We can no longer afford to miss out on the talent and skills available if Britain is going to compete in a fast-moving global economy. Looking wider, having a better diverse balance within the workforce will mean that employers benefit from fresh perspectives, talent, new ideas and broader experience which leads to better decision making.

This notion that we need to have disabled people in more senior positions is good, surely then a top down ripple effect in diversity would be inevitable. I couldn't engage a Minister in this debate without posing the question of Access to Work that Martyn had been talking about. I winced when asking this question as asking any politician about cuts is not a popular

subject but I was delighted that Ed did answer it and his answer was something I hadn't considered at all. How can we achieve diversity targets with a reduction in financial support?

Access to Work does not subsidise or replace the provisions of the Equality Act. Employers will still be required to meet their commitments under the Act, including the legal obligation placed upon them to make reasonable 12 adjustments for disabled employees. Any disabled employee who feels that their employer has not made reasonable adjustments can legally challenge that decision under the Equality Act 2010.

This is a very fair point. We forget sometimes that film sets are still places of work, much like an office or a factory. They are required by law to make adjustments. The closing or reduction of access to work does not negate the responsibility of the employer, it simply reduces an ability to be able to offset some cost slightly.

I genuinely feel that Ed Vaisey's passion for diversity stretches beyond his remit as a Minister of State for Culture and the Digital Economy. Watching him chair the roundtable he is not just lending his name to the issue, he is actively trying to change the landscape. My final question, given his passion for the subject was, what would you like to see happen in the next five years to achieve diversity?

I would like to see a creative industry sector where disability is less of an "issue" because the way that the industry functions will be such that it is inclusive and that there are the opportunities for people to work and express themselves to the best of their abilities irrespective of disability or race, gender or sexual orientation.

We are starting to get a deeper understanding of disability and diversity, from a Ministerial perspective through to an entrepreneur working in the heart of the employment sector. It is complex and takes in factors on economics, healthcare, employment attitudes and opportunity. In its complexity is its strength, as storytellers we want the complex and the interesting. So how do we lift the lid on this undiscovered world?

"Disability has coexisted with humanity since the beginning of time. It is not new, it is older than religion, race, and sexuality. Since the dawn of mankind there has been impairment, injury, disability and deformities. So why is disability the last minority to receive focus on equal rights?"

Presenting and the Corporate Sector

Before we look at the world of fiction let's consider the possibilities for disabled people in the world of presenting and corporate work.

Post 2012 we have seen a nice increase in the number of regular disabled presenters on prime time TV. The beauty of this is that you are showing reality, even if a documentary is part scripted the presenter is appearing as themselves. In my experience this is a little more daunting as you are not hiding behind a character, you are letting your own persona show for the audience, this can be intimidating. My nerdy anxiety aside I have always liked this. It's direct, it isn't a fictional scripted representation, it is pointing the camera at reality and pressing record. We will touch upon sustainability later in more detail but this is an area where broadcasters could really help to supplement income for new disabled artists. Keeping in mind that presenting is an art in itself and it isn't a straight-forward transition, however there are transferable skills in both disciplines. The ability to be directed, good diction, and a strong ability to improvise are just some of them.

Presenting can come in the form of live broadcasting, pre-recorded items and documentaries, to name a few. There is a current trend especially with the BBC One Show to hire a disabled presenter to present pieces relating to disability. To be fair and balanced this may be more possible due to Channel 4's work around 2012 in finding more disabled presenters. Either way it is refreshing that this is becoming the new landscape in

presenting, long may it continue. I hope we also see a trend that disabled presenters are able to present on topics not related to disability.

With presenting it seems that live broadcasts are the pinnacle of a presenter's career and to be trusted to work on these shows you have achieved a certain level of competence. Pre-recorded segments and documentaries carry the ability to be inclusive of even the most severe disability. Time can be taken to approach the filming in the correct way and any communication barriers can be overcome. A powerful documentary can change the world, the knowledge that it is a true story and a documentary often makes any drama a much deeper emotional journey.

In order to really push the boundaries of how documentary can lead the way for disability representation it is important for commissioners and producers to find the stories and actively engage the disabled community to un earth content. In my experience it is hard for disabled people to connect with industry professionals that could commission a documentary. We will cover this many times but having disabled people as part of the creative process from the beginning can lead to breaking new ground on screen.

Corporate work links very closely with presenting. Although work as an actor on adverts would be covered under the section on acting, we must remember that the corporate world also includes voice-overs and still image. There was a dramatic increase in the number of disabled athletes used in high end brand marketing in and around the 2012 Paralympics and they have continued to attract corporate attention. This is a strong

indication that the world of business understands the strength of inclusion of disabled people.

One area that could be pushed is the area of voice over work for advertising. When voicing a character for Radio or TV as an audience we are blind to the disability of the person voicing the character. When we talk about sustainability it is important to remember that in voice over work there are no restrictions at all on casting, a voice is a voice. It is such a shame that this isn't being pushed as much as it could be. In the UK radio still plays an important part in our broadcasting industry.

Corporate work is well financed; it can be a very lucrative revenue stream for disabled artists who are waiting to secure "in vision" roles. However, there is a dark side to some corporate work at the lower end of the spectrum that should be more widely reported.

In practice most disabled artists at some point at the start of their career will be asked to take part in corporate roll play activities/training videos and have to suffer playing the person being discriminated against. It is worth noting to other people in the industry that this does happen. Over many years repeatedly being asked to play the helpless victim of corporate discrimination can take its toll. This in part must generate a certain sense of ill feeling. This is not something that is asked of able bodied actors, although those from an ethnic minority may also have to endure this kind of employment. For a disabled person having to repeatedly play the victim so we can all learn "how to deal with a disabled customer" is demeaning. It is only done out of shear need to financially sustain a career. The only point we can take from this is to have empathy with

disabled artists, there are a lot of very demeaning things that may have been asked of them.

We have yet to identify all the barriers to inclusion for disabled artists but it is worth highlighting that in presenting, voice-overs, and marketing campaigns those barriers are reduced, if not eradicated. It also doubles as a great learning tool and an inexperienced artist can gain much experience and knowledge from working in these roles. In many ways they are gateway opportunities and can help sustain careers. As a disabled artist it is important to understand these opportunities and seek them out.

As a slight footnote it is a lot easier to increase disability representation with disabled presenters, the barriers facing actors is far greater, presenters are a quick win. If broadcasters are looking at a generic numerical amount of disability on screen it is important the increasing the number of presenters does not negate the responsibility to tackle the issue with actors. I would suggest taking a look at the percentage of scripted to non-scripted shows within your output and ring fencing targets accordingly.

The next section is covering language and tone and is also applicable to presenters.

"Attitude is a great word when talking about disability, society has an attitude towards disability, and disabled people need a strong attitude to deal with society…"

Language and Tone

Let's get Language out of the way shall we? As it's the one thing that makes people run for the hills. This is an ever changing, subjective topic that there are very little hard and fast rules for. It's important to look at it from the point of view of what is derogatory. So, let's look at some in a bit more depth:

Cripple – The good old raspberry ripple. Well yes this is the most offensive "C" word that you could use, and like the use of the "N" word in ethnic minorities there is a small trend by disabled people to reclaim this word and use it for ourselves. Personally I have more respect for myself to refer to myself as this. Some disabled people like using it but I am pretty sure all disabled people would not want a non-disabled person to use it. It might be ok to have one disabled person in a show refer to himself or another disabled person as a "crip" but I would steer clear of having a non-disabled person use it. I would also recommend a different character questioning it's use in the same scene if it is used.

Spastic – Isn't this one a little old now? It's almost a retro word for disability and one not well known by the younger generation. It was kind of around in the 90's but we don't hear it a lot these days, thank goodness. Avoid at all costs.

Handicapped – Oh I hate this one, and the Americans use it all the time! In French it sounds a little sexier "Personnes handicapées". In French it sounds like something you are offered by a waiter on a silver tray at a fancy party, in English it sounds like we've all lost a hand. I'd steer clear as it really has got a negative vibe to it and I think it's a little old school.

Invalid – This one is even worse, makes us sound like we are all laying in a bed somewhere dribbling. I think it's more that it implies you are unwell, unhealthy. Could you imagine referring to one of the Paralympic athletes as an invalid? If you do make sure it isn't the guy with the javelin.

Disabled – It is what it is. Most people don't have a problem with regular good old disabled, it's the lesser of many evils. There has been some call for the use of "non-able" but if we go down the road of listing what we aren't it will get out of hand. I'd be a "non-six pack, non-tall, non-blonde". You get the point. Let the disabled be the disabled. It does imply lack of ability which has a slight negativity to it but we have to have a way of saying it, and this is the least offensive in my opinion.

Differently Able – forgive me if you say this to my face and I laugh inside. The PC brigade would approve but to be honest it's a step too far. I for one am proud of my disability, it's part of me, so I don't like this as it implies I have a problem with my disability and in some way am hiding from it. I'm not, I am disabled and proud to be one of the 11 million.

Suffering with… - I don't like this but it's used a lot, I don't suffer with Spina Bifida, I have it. I suffer with a headache or man flu, but for the most part my disability is stable. I would much prefer to say **I have a condition called…** that to me is a lot nicer. I can then leave the suffering to my man flu.

A wheelchair - This one just baffles me if I was on a bicycle would they refer to me as a bike? In everyday life I often get referred to as "a wheelchair", this I don't like. When

out and about and asking members of staff for help the amount of time they get on the radio to a colleague and say "I have a wheelchair waiting for assistance". This shocking event happens every day and I hate that they refer to the wheelchair and not the person in it. I mention this as it's not about language really it's about how you address a disabled person as a person. If someone is genuinely trying to not say the wrong thing and are talking to me as a person, then I am always responsive. It may shock you to know that at the supermarket I have paid for items and the checkout operator has handed my change to the person with me. I have been queuing for food and had someone ask "does he want chips with that?". All these things do happen and are largely down to very big misconceptions of disability. Please see the section later in this chapter about Objectifying.

Please don't panic about talking to a disabled person, but actually talk to the person, not the disability or mobility aid. You won't be the first nervous person they have ever spoke to and you won't be the last. You will only encounter problems if you are really ignoring that person or saying things in a derogatory way.

Try and avoid telling them that you knew a guy in a wheelchair once, or spend summer in one when you broke your leg. Although very cute, this isn't really something that has given you an academic knowledge of disability. Spin it on its head, I meet a guy and say, "I spent the summer walking one year." It's just a little weird. Always think how you would like to be spoken to if you were in that situation.

In terms of onscreen language, we have to consider that history has not been nice. If you are setting something in

1920's they will refer to disabled people as cripples and invalids. In the 90's it will be spastics. Luckily some words become inappropriate, but we shouldn't hide the murky past. The disability rights movement has come a long way.

As I said before this is an ever changing subject and very divisive, but if you mean well and just talk to the disabled person in the same way you would anyone else, you can't go far wrong.

Before we look at tone, one point that can be tricky is "how to discuss disability issues with a disabled person?". For anyone developing projects and actively engaging disabled people in a project that features disability, you will of course have to have in depth discussions about disability issues. This is such a vital conversation to have but it is understandable to feel slightly nervous in how to facilitate the discussion. In truth the more questions you ask and the deeper understanding the better your film will be. In my experience Producers have always handled these conversations with respect and created an atmosphere that made it comfortable to share some pretty sensitive issues. With these discussions stories can emerge that are so powerful they alter the course of scripts. It is nice if the conversation is a series of questions from the Producer and writer to gain more understanding. If a disabled artist has agreed to help, then they are willing to enter into this discussion. It might be best to start by reassuring the disabled artist not to feel pressured into talking about anything they don't want too and to explain the aims of the film, the story and what stage it is at, to explain how their input will be of help. As storytellers we all find stories interesting and this transcends disability, so feel free to share stories where experiences have been similar. The best meetings I have in development are over

a cup of tea and to chat about the themes and issues in the script, relating them to my life and with the Producers relating bits to theirs. The best scripts allow us to empathise with characters, to see a part of us reflected in it. For disability the reflection has at times been an altered image of what society thinks we see, by discussing scripts at development we can make that reflection closer to the truth.

Tone

It's important to consider tone when writing for disabled characters as this is an area that can create problems. Even if the language you are using is not offensive you might still generate complaints through the tone of your script. This would have been put in the writing section but it is important enough to give it greater prominence. For a representation to be strong the whole team must be considering the tone. The problem with tone is that it is between the words, it is the mood created by the writer and as such it's a little harder to cover in terms of advice. It is possible to gauge when reading a script if it comes across as patronising, or feels like the disabled person is a victim. I'm not going to give any hard and fast advice on tone other than to say be aware of it. In terms of commissioning it is one of the biggest areas of concern as commissioners will want the tone to be right.

Tone is a big stumbling block for development, as an idea progresses from treatment to script it can evolve. When considering a disability related project or character the tone is hard to assess just by a treatment. In experience it requires in depth conversations on how it might be realised and what to expect from the script. In truth having the script overcomes this, but scripts cost money and with limited resources

financiers are careful of commissioning something they are not 100 % sure of. It may be worth at this stage bringing in a disability consultant. I don't mean an expensive company or major expense but find a disabled writer or artist, ask them to sign a simple non-disclosure agreement and have them read over the treatment for a small fee. Or have a couple of disabled artists do this. With feedback you can make an informed decision on the best way forward, or if the project is worth taking to script. This is a reasonable adjustment to make on projects with disability that will not break the bank. It is a good start to the project and creates an informed view point to facilitate greater decision making.

Once you have a script, any problems with tone can still be addressed. I was once asked advice on a script where the tone was the problem, without knowing what it was the director just felt something was wrong. Without being able to put his finger on the problem he suspected that had it been filmed in the way it was, complaints would have been likely. This was a BBC script that was shooting in a matter of weeks, it had been fully developed, commissioned and still the director felt uneasy. By talking through the script he was able to change it and alter the tone. It was a simple amendment that involved a few dialogue tweaks that changed the emphasis of the scenes and retained the original story. The amendment made no financial impact to the project. In a way tone is almost instinctive and borders on common sense. If you feel like something isn't quite right, it's a good chance it isn't.

One of the most common errors with tone is "objectifying". When you look at the history of any rights movement it is clear to see that the oppression of any group has been enforced largely by de humanising people and seeing them as an object.

It is easier then to treat them un favourably as they are just an object. Whenever two people are discussing the needs of a disabled person in the room with the disabled person but not engaging them in the conversation they are de humanising them. When a person is referred to as a "Wheelchair" they are de humanising them. Disabled people are not an object; the presence of a health condition does not make us less human. We are covered by every single article of the Human Rights Act and no disability removes those rights. There is a big difference to objectifying a disabled person and showing the care system they have in place around them. Those systems only exist to enable the disabled person to live in an inaccessible world. Any portrayal that objectifies and de humanises the disabled character must be challenged.

The most recent example of a film that gained criticism from the disabled community for problems with tone is Me Before You. Without giving my personal review it is fair to say that this generated a lot of national and worldwide press about its disability theme. The main criticism seemed to be that the message seemed to suggest it is better to commit suicide than live with a disability, despite the wealth and privilege of the lead character. It was argued he had everything to live for and the argument of why he wanted to die didn't seem to resonate with the disabled community. The film also featured an able-bodied actor playing a disabled role, which added fuel to the fire. The writer and director have defended the story and we must understand the genre in which this sits, it is aimed at the emotional romantic comedy audience. Its intention is to draw you in and almost certainly pull on heart strings at the end. To that extent it is not trying to be a hard-hitting factual drama, the focus is on the emotional pull much like most novels in this genre. Having read the book and watched the film it is an

interesting piece to look at if you are planning a project with disability in it. It is interesting and it brings up a massive word in the world of disability, one that is powerful and must be considered. The word is **Pity**. What the film and the book do on many occasions is make you feel pity for the disabled character. For those who know your equal rights history the UK disabled community in the early 1990's closed down annual Telethons aimed at raising money for the disabled holding banners that said "Piss on Pity", action which lead to the formation of the Disability Discrimination Act of 1995. It seems that pity is not something that disabled people have ever wanted or asked for. By firmly placing this story in an area where we are meant to pity the lead character in order to achieve the emotional response at the end, the novelist has entered into a very tricky area. As with all films and books, opinions are just that, they are opinions, I would urge you to read and watch the book and film to explore your thoughts. However, I think it is fair to say that even if you think the criticism was justified or not, having a large section of disabled people campaigning outside your premiere is something one would want to avoid. Whenever you are suggesting that disability is worse than death, or that we should all pity the disabled it will draw strong feeling. Of course, for people that have life altering events take place dark thoughts and suicidal moments can happen, that isn't a disability thing, that's a human thing. It is important to be very careful with representations of disability that are heading into these very dark themes, the obligation goes beyond that of making a good film and falls more into how it might influence vulnerable people that are in similar situations. We have a moral obligation to get these things right.

To connect to the audience and get them to fully engage in the portrayal of disability language and tone have to be closely monitored and considered. It is in these two elements that most of the fear of getting it wrong exists. It would be heart-breaking to think that this fear leads to producers and writers not wanting to attempt writing for disabled characters. At times it feels that complaints about disability representation are more harmful than good, as we should look to support and encourage representation. Getting it right is not black and white, it is extremely difficult as every disabled person has a different view on what is acceptable and what isn't, you can't cater for every opinion. In my own projects all I ever consider is can I defend this decision? Can I say that we considered this and all agreed that this was the right use of language for this piece, and the right tone for our narrative? If I can satisfy my own fear by justification and consideration of all the factors then I am happy that for the most part people will see that both the tone and language are artistic decisions, and not un-planned offensive mistakes. The best practice would be to have these conversations and consider the language and tone, and then seek out opinion. Manage the risk by taking steps to show you have thought through every step and each part can be justified, as it will be you sat at a Q and A at the films launch having to answer the questions, best to get them answered sooner rather than later.

"You cannot represent what you do not understand…"

Writers

Writers have the ultimate control in creativity, at its very essence they have the ability to create characters with disabilities. If the piece they are writing is looking at being representative of society then they should be making at least one character disabled in every production. This does seem like a token style approach but it is a necessary one to get the numbers of representation up and to increase job opportunity. Research is the key, and can be the difference between accurate portrayal and miss-representation. If a writer writes it, a casting director will try and cast it, an artist will be hired, the artist will be paid, a portrayal will go out and it is that simple. It all starts with them sitting at a computer and typing the word DISABLED.

You want to write a disabled character, what next?

Avoid stereotypes or creating new ones.

Historically disabled people have been portrayed as weak, dependant on others, a burden, or a villain sat in a wheelchair stroking a cat. A disabled artist is more likely to turn down a role if they feel that they are being asked to play one of these types, or worse, they may have no financial choice to say yes and hate doing it. This does not mean that a disabled person can't play a weak character but it is important that the weakness is in relation to another human attribute i.e. gambling habit, family problems etc. On the opposite side of the spectrum it is creating a new stereotype if you make all disabled people strong dominant characters or at its extreme using the bond villain example, suggesting that people with

abnormalities are a social menace that want to take over the world. A disabled character can be evil, cruel or strong, there is a happy medium and we can navigate these tired stereotypes and find something a little better.

When it comes to characterisation concentrate on the character and then add in the disability. For example;

A female character that is in debt due to a relationship break up. She is living in a small flat in a bad area due to finances and is trying to rebuild her life. She finds opening up hard due to being hurt by her previous partner.

(Add in the disability) She is deaf and lost her hearing when she was young. She is independent but her disability adds to her fear of opening up, and is making finding a job harder.

Write the character first. Not forgetting that the disability can add flavour and depth after. The biggest thing about my personal character is not my disability, it's the fact I am a geek, that's why in the "About me" section at the end of this book I introduced myself as a geek, before saying I am disabled.

It's a numbers game

In simple truth the more disabled characters you write, the more there will be. Initially the sad truth is that to get programmes commissioned they are likely to be the supporting roles as very rarely do we see disabled lead characters. This isn't as bad as you think, as an explosion of supporting parts in various shows could be enough to gain real momentum in disability representation.

Where to begin? The internet is an amazing source of information on disability, and for almost every disability there is a charity out there that can assist with specific information that can help you write more complex scenes.

You can also research artists previous work, find someone you like and write for them. Even engage them in conversation at the development stage.

If you are still struggling at how to start, look within the industry and production companies that have produced disability related work before and contact them for advice.

It is also worth noting that some financiers have a specific remit to actively support works that cover certain topics, disability touches on medical, sporting and other themes that could open up avenues to you actually receiving a commission to write your script. Most of these sources for funding are looking to support you to conduct thorough research and in doing that your script becomes stronger. Don't think of it as a problem, think of it as something that could open up opportunity for collaboration, open up funding avenues and strengthen your final script.

To reiterate as a writer, it is vital that you remember the difference between acquired disability and those born with conditions.

Two words should resound in your head about disability **Quantity** and **Quality**.

The best portrayals of disability seem to happen when the disability isn't the storyline for the character, maybe they

feature in one or two episodes later on but for the most part they are just them. The best example of this is Walter Junior in Breaking Bad, his disability was hardly mentioned and this is typical of a normal family unit. Disabled people don't wake up each morning and say "I'm disabled", if they are like me they are normally just arguing with the alarm clock.

It's more an idea of being clever with the script, finding people that interest you, and if need be, taking a different approach. Don't just make everyone a soldier returning from Afghanistan with PTSD, as it's the latest trend. Go deeper, plunge into that uncharted water of disability. Peel back the layers and find the golden nuggets of drama that only disability can portray. Study the work of Jack Thorne, who has done this, his work is so informed and on point.

Most of all don't fear it, just do it, you'll be amazed at the rabbit hole you are starting to peak down.

To get a better understanding of disability from a writer's perspective I asked my friend Paul Viragh (Face of an Angel, Sex Drugs and Rock and Roll) his thoughts on disability representation. I am currently working with Paul on a project with a disability element and his writing is always thoroughly researched and meticulously developed.

I asked him what attracted him to disabled characters and stories?

"The stories are original, surprising and unusual takes on the standard character arc. They are all still very human stories. There tends to be more grit in them and the different

angle on familiar personal dilemmas injects them with urgency and emotional impact."

I was glad that Paul backed up this notion of fresh ground and adding something to a script. I was keen to see how Paul approached writing disabled stories and characters, is it any different?

"No. I am looking for great human stories. People overcoming difficulties, being tested, dealing with life love and death. Stories that bind us together, regardless of who we are where we're from, are always the best."

What would your advice be to writers looking at writing for disabled characters?

"Ian Dury said "everybody's got a disability of some sort" whether it's physical and obvious or not. I would hope without giving advice that writers and commissioners are always looking hard for the best most surprising stories to cover the whole world of experience, and that would include disabled characters too."

It was nice to hear that for Paul the approach was no different to the due diligence he pays to the rest of the script, and that unique strong stories appear to be the biggest benefit he would highlight to other writers. Finally, as Paul and I often get chatting for ages on all subjects and his view point is always interesting, I asked him what he would like to see happen to help disability representation.

"Just a waking up to the fact that a large percentage of the population are disabled, and that their emotional experience is

the same as everybody else. They are not, as some newspapers would have it, only either "inspirations or scroungers" These are lives being lived fully. Also being disabled is the only minority you can wind up in tomorrow. It's of interest to everybody."

I love his point that disability is a minority that you can find yourself in overnight.

It has to be said that even as a non-disabled writer Paul has considerable insight into disability. It would hope that more writers can become as informed and knowledgeable of the disability community. From the perspective of writing it appears disability has a lot to offer and adds value to scripts. This is vitally important as this is the critical moment when a representation of disability can be born.

Once it is down on paper, the next link in the chain is getting it commissioned, so let's look at that.

"Disability equality in media is inevitable, the voice and will is too strong and the arguments against too week..."

Commissioners and Controllers

This is a really important section, as commissioners and controllers are in a position to be able to really create change. They have the power to stop projects that do not encourage diversity, they have the power to commission new voices. Having to keep a watchful eye on the current market and the needs of the channel or network, they are the gatekeepers to true equality. It is easy for a commissioner and controller to say "we want to find new unique voices" but let's discuss this, as it is a powerful statement but not easy to achieve.

The vast majority of new disabled artists will not enter the industry in a conventional way. Some natural born talent is being hindered from attending drama school, university, and film school. Also, it is well documented that a larger percentage of disabled families live in poverty, so there is also an economical barrier to higher education. The medical needs of a late teenage disabled person might also prohibit moving away from the family unit to live independently at University. Until we are one hundred percent sure that enough disabled people are having the same level of education and access to specific industry training we must keep an open mind on expectations from this new voice. It is vitally important that training is conducted to counterbalance this shortfall in disabled artists being able to train in a conventional manner.

A new disabled actor probably won't have attended drama school, but there is no reason why a broadcaster can't arrange private tuition with a drama coach, or a dialect coach. No true

artist will ever turn down training at any point in their career, there are always skills to learn and a craft to develop.

A script from a new disabled writer might not be as polished as one from a seasoned writer; it might not come via a literary agent. It will need to be developed, you may need to add an established writer to make it stronger, you will need to package with an experienced director and producer. Your extra work will be rewarded with bringing an authentic voice to the screen.

A disabled producer might not have gone to film school. They might still have a valid, commercial viable film that has potential. An inexperienced producer can be paired with a veteran producer. Just because the producer does not have a track record or training does not mean they should be ignored. If the film is worthy of development it should be developed.

I have to say I am lucky to be currently working with some amazing, open minded, and committed commissioners who get this, who understand that these projects aren't going to follow the normal pattern. They are asking hard questions, they aren't in their comfort zone, but that's exactly why they are working on them. We have all seen the same old film time and time again and I get a buzz when I hear a commissioner say "this feels fresh and authentic". Fresh and authentic don't come easy, they have to be found and developed carefully.

In 2015 the BFI made a decision to encourage the UK film industry to go further and to become diverse. With an introduction of a new commissioning policy they demonstrated they were taking a very bold stance to ensure that every project met tight diversity standards.

The benefit of this is twofold, it ensured all BFI funded projects were focusing on diversity, but it was also a big enough policy change for the industry to really pay attention. This is direct action, instead of just hoping unique projects come in, the BFI incentivised it, they gave producers a good reason to make a difference.

I caught up with Ben Roberts, Head of the Film Fund at the BFI to discuss this more. I wanted to know what prompted this policy change.

"Several reasons really. Most obviously, anyone who applies for funding from us will know that there are already a LOT of guidelines and criteria for public funding, so it felt odd that we didn't have anything pertaining to diversity. Beyond that, there is a general sense that progress in career opportunities, talent development, diverse audiences has been slow – possibly stagnant - for too long, and this just isn't good on creative or economic grounds, so we all needed to lob a couple of large ideas into the mix."

The large idea they created was a "three ticks" policy which you can find on the BFI website but it covers use of disabled artists and other minorities both on screen and off screen. I remember emailing Ben shortly after it was announced and simply saying thank you, for me it was such a relief to have such a big funding body putting all their weight behind diversity. They had consulted many people and really listened. Not only that, the policy had a significant ripple effect on the rest of the industry. For example, a few months later Channel 4 updated its diversity policy. It brought the issue back to the table in a very positive way. I asked Ben if this had always been the hope?

"Yes we decided not to approach this as a 'scheme". Schemes have a habit of coming and going, everyone remembers old schemes that may have been good while they lasted but were generally retired and so had little or no long-lasting impact. What we want to do is embed an expectation of good practice into the things we support, to set this as a standard across the industry that others can adopt, and then it will be very difficult – hopefully impossible – to remove them."

Like any attempt to be diverse, the one thing we all want to know is, did it work, and have we started seeing the benefits?

"We saw some immediate benefits in terms of how producers were engaging with the guidelines, challenging themselves to respond to them, asking a lot of questions about how they could do better. We saw small but meaningful changes in how films were cast and crewed. It has also helped us to confirm the areas that are the biggest challenges – diversity of crew being I'd say the biggest. Longer term, we hope that they will help to establish a 'new normal' in terms of behaviour."

This policy change comes from a knowledgeable vantage point of the whole industry and how the BFI play a part in that. I think it's a brilliant example of something that works. I think it is a big reassurance to other commissioners that there is little to fear and that at the highest level you can ensure diversity is a continued priority. It's encouraging that Ben's view mirrors my own as I asked him what he thinks would help disability representation outside the scope of the BFI?

"I think everyone has to get entirely comfortable talking about disability, working with people with disabilities and seeing/accepting disability. There is still bit of a "them" and "us" gap. We talk about diversity as "the quality of difference" but equally I think we have to get to a point where those differences aren't considered to be so profound. Non-specific representation. Practically-speaking, I think that means a greater level of mixing, networking, working together, onscreen and offscreen. Getting used to each other. Encouraging casting directors and other department heads to consider everyone equally would also help dramatically."

I love Ben's thought of an "us" and "them" feeling and we will touch on this in the section about experienced artists as both sides are guilty of this and working together can eradicate that gap.

We are seeing changes at the highest level of commissioning, and have touched upon being open to new voices from unconventional sources. We've seen that writers are very attracted to unique stories and strong characters. So what about the people leading this projects? The Executive Producers and Producers, let's take a look at things from that perspective.

"The new attitude to disability should be that if you are not doing all you can to be diverse, you should feel a great deal of shame. This is the only attitude to disability that everyone should have..."

Executive Producers/Producers

In many ways the task of an Executive Producer or Producer is the hardest one, as they are the ones who have the sleepless nights about production. They are responsible for delivering the production on budget, on time, and without anyone getting hurt. Putting a disabled artist into a production might seem like a massive risk and one that should be avoided at all costs as it is expensive and a lot more work to do. But is it really as much work as you think? In this section we will explore the factors and look at the benefits of authenticity.

Many of you may be aware of the term "blacking up" which refers to Caucasian people playing characters from ethnic minorities. It is important that using a non-disabled artist to play a disabled character is frowned upon in the same way. There is a small amount of exceptions, but it is a very small list and a very divisive topic. The current marketplace sometimes requires a disabled character to be played by a non-disabled artist, this is normally due to the box office draw of the star and goes into film financing. That's understandable, but we shouldn't hide behind this forever, let's make someone who has a disability a high profile artist, by providing a career path for it. This is a problem that is mostly limited to film. As with film you need the star to get the finance, but surely TV isn't as restricted? Surely TV, depending on the broadcaster has an obligation to get it right? Could TV be the gateway to making 'names'? We will cover this later in greater detail, especially in the section for experienced disabled actors, in an aim to offer a different perspective to disabled artists, especially any disabled

artist that has ever complained about an abled – bodied actor being cast as a disabled character. I would recommend producers reading this section.

Having started by explaining that "Cripping up" is now frowned upon and you can expect a backlash, lets discuss the financial impacts. As a producer you are always playing a balancing act between what you want, and what you can afford. Budgets are tight and saying yes to one thing normally means saying no to something else. You have to prioritise and work hard to deliver a high value product. Luckily Jobcentre Plus runs an access to work scheme and can cover additional costs of employing disabled people. Two recommendations are; apply early, and get as much information on what you can claim as you can. Costs can be applied for transport, support workers and pretty much anything that would not be needed for a non-disabled actor. The scheme is to ensure employment opportunities are not reduced just because people with disabilities might cost more to make reasonable adjustments for. In saying that, like with everything at the moment, this scheme is suffering from cuts. It has started removing vital services from people. It is still worth considering but you might need to form a better argument for it. Be prepared to fight, but listen, you fought to get this project commissioned, didn't you? If you can get Film/TV finance, then you are probably pretty good at application forms.

What other reasons are there to ensure authenticity? Your funding may actually be dependent on diversity, as we've seen with the BFI. The new wave of thinking among commissioners that if you are not offering diversity in front and/or behind the camera then you are not going to get the commission. In this sense, any potential cost of a disabled artists is swallowed by

the financial gain of having a diverse project. Surely most producers want to be diverse, and it isn't all about the money, but it's good to see that we are starting to see it as a financial advantage.

With disability in a project your scriptwriter is benefiting from having fresh characters and story to work on and your film has a unique selling point. It moves away from being something we have all seen before and towards something exciting and new. However, who is your audience? As you may worry about marginalising this piece. Can this still be mainstream and commercially successful and inclusive for disability? Why would non-disabled people want to watch disabled people? Why do we watch celebrities in reality TV shows? Curiosity! It is human nature to want to learn, understand, and appreciate all parts of life.
Post London 2012 there is an appetite for disability and it is showing no signs of slowing. Your primary audience should not be reduced by disability only enhanced. As mentioned at the start of this book, you are opening up to a £212 Billion market.

As a strong secondary audience, attracting the disabled audience is a simple psychological trick. Imagine as a disabled person the recognition of seeing a disabled sign on the floor of a car park or on a toilet door. Physiologically my brain tells me that I belong to that group and that these are for me. Similarly, when I see disability on screen, I take more notice as I categorise myself into a group with that person. This is due to deeply embedded views of oneself in terms of social identity. It is the same social cohesion experienced by football fans of the same team, they see their football logo and instantly know they belong. It is an unconscious response by my brain that I have

little control over. It's a trick that has been used by advertising agencies for centuries to sell washing powder to housewives but now we can harness it to engage the disabled community. By inclusion of disabled artists, you are appealing to that cross section of society and opening your production up to a larger audience. In these terms, it makes no sense whatsoever leaving this section of society un touched. If you were a politician you would want to tap into 11 million potential voters?

Now let's talk about complaints, as you will get them if you are not authentically portraying disability, it will get you some serious backlash and quite rightly so. Don't do what some shows have in the past and make the character stand for one scene to justify a non-disabled performer, actually use stunt doubles and get smart about the way you film. It will give you a nice story for marketing the film after, think of it as good PR, it raises the social value of your film.

Disability Offset.

If for any reason a disabled role is having to be given to a non-disabled actor, challenge yourself to offer opportunities to counter balance that decision. Could you hold a training scheme offering vital training to disabled people? Could you cast one of the other parts with a disabled actor but not mention or make known the switch? How can you cancel out the damage done by removing that one employment opportunity to people who vitally need it? We have all heard of carbon footprint offset, why not try a disability offset. If you remove one job opportunity but give three elsewhere you are at least fulfilling an ethical obligation and taking positive steps towards diversity. Just remember my simple little poem.

Disability offset rule for thee, if you give away a part, you must give back three.

Before we go through some technical tips and bits to consider that you might find useful, let's see the viewpoint from one of the nicest Executive Producers in the industry. Diederick Santer is my old boss from my days on EastEnders, and I really enjoyed working with Diederick and the chats we had. I am always taken with Diederick's calm nature and he is beyond generous with his time. He has been responsible for some ground-breaking portrayals of disability and he makes it look effortless. In his current job as joint CEO of Kudos he is not only heading up some of the UK's greatest shows but also looking to develop stories and characters. I picked his brain about the appeal of correct representation;

"I'm not sure there is a 'correct' representation. For me it's about reflecting the audience and trying to do something to show, and perhaps at times celebrate, that there are all kinds of different people. For me it's about range, about doing different things, about taking the burden away from individual performers and representations of having to reflect the whole disabled experience. For example, sometimes I might want to tell a story where the disability is the story – it's used as an issue, but hopefully not exclusively as a problem or an obstacle to overcome, or as the sole defining trait of the character. Other times it's good to find the chance to do 'disability blind' casting, where we apply imagination and cast a disabled performer to a part that wasn't originally written as such. It's important to not be daft with this – it will just irritate the audience if it feels wrong (eg casting a wheelchair user as a roofer), but why can't the teacher be someone with dwarfism or the scientist be deaf? Both approaches – disability as the

subject or as something incidental – are interesting and correct."

I love this, as it's a twofold approach, sometimes the disability is the story you are telling, sometimes it is incidental. Diederick has a great track record with both examples. What's been the benefit of that work?

"It's exciting to tap into a relatively unexplored group of performers and to feature them in big shows. It's rewarding to show experiences on television that the audience haven't seen before, and to tell stories from new perspectives."

This really does link in to what Paul was saying about new stories and characters. It's interesting that we are seeing a pattern of the industry really liking difference and the excitement of it. Even though Diederick makes it seems so effortless, largely due to his nature and talent as a producer, he must have had to overcome challenges. I asked him what he felt the biggest barriers to disability representation are?

"It's imagination, or conversely fear of getting it wrong. Producers live in fear of doing something that isn't 'correct' or of being offensive, so the safest thing to do is to not apply imagination and take risks. I'd argue it's better to try and fail, than not try at all, and that you probably won't fail if you apply imagination and talk to people.

It's also true to say that the pool of disabled performers isn't massive. There are brilliant performers, but I want to see more, I want to have more choice. The cause of this of course is lack of opportunities in the past, so it's down to producers, writers and directors to create roles now, thus making work, thus making performing a more fruitful career, thus deepening

the pool. Having said that, the pool is probably deeper than most producers think – it's about applying imagination, asking questions, and going looking for people."

It's nice to hear an Executive Producer begin to talk about supply and demand, and that there is a little fear of getting things wrong. From what we have heard from Diederick and Paul is that there is an excitement about disability that should overcome this fear. Where there is a will there is a way. Diederick is right about the pool of talent not being massive. We do need to keep recruiting talented people. I couldn't resist asking Diederick a very similar question I put to Ben and Paul, which was, what would you like to see happen to help disability representation?

"It's up to everyone – writers, directors, commissioners, and performers to ask the question. Why can't this show have greater representation? Why shouldn't a disabled actor be considered for this role? We all have to play our part and ask difficult questions."

It's interesting that we really are seeing a consensus for everyone to work together and all take responsibility. It's great for me to hear that echoed in people that I greatly admire, in people that are working at the highest level of our industry.

If this resounding positivity to inclusion has tempted you to become slightly more diverse in your work but you are still a little hesitant of getting parts wrong, the following parts offer you some brief tips to get you started. As my esteemed colleges have all said, the answers to everything you need are out there, it's about asking the right questions and engaging the right people, to harness that exciting slice of life.

Pre-Production

For example, you have decided to use a disabled person in your project and are now looking at production. This is where you need to work closely with your writer(s) and casting director. You have two options. Find the artist to suit the role/disability, or find the artist you want to work with and mould the part accordingly. The first option is very hard to do, as everyone is different. The chances of finding the performer you like, with the required disability, right age, look, and availability, well as you can imagine the odds aren't on your side. However, option two is easier, have a basic idea of what type of disability you would like but be open minded to tailor making it on finding the person. Make them one of the first people you cast to give you time to apply for any access to work funding and develop the role. Talk to the artist and discuss needs and work with them to make the production as good as it can be.

Production

Unit base and locations need to be discussed and any adaption's made, for <u>each unit move and each location</u>. Be aware that three ways and star wagons are not normally wheelchair friendly and you either need to consider ramps, which are available but expensive or alternative rooms for your artists. I have spent many productions in a posh inflatable tent, they are pretty cool and you become the envy of the other cast who loiter in your tent at lunch. Makeup trucks aren't so bad as it would be possible to get the makeup artist to come to the artist's room. Work closely with your second AD and locations team to get them to ensure the unit base is as accessible as

possible. Consider using flooring to cover excessively muddy or gravel sections of walkways around Unit base.

Disabled toilets will be needed and additional help from runners required at meal times due to catering vans being inaccessible. Ordinarily I have gone to the steps of a meal truck and they have come out to serve me but having a runner on standby is handy.

Locations can be tricky. Once you are out of the comfort of a sound stage things do get a little harder especially when you are changing location every day. Planning and common sense is key. Don't assume that something is OK, check with the artist. Grass, cobles, gravel, and hills are kryptonite to wheelchair users. What someone will need changes according to the environment. As much as it might seem a pain to keep pestering the artist a five-minute conversation can save a huge embarrassment. Please try and optimise routes to set, having to go the long way around a building every time you are called to set is annoying. Consider integration too as segregating the artist from interacting with other cast during lunch can be isolating. Instead of trying to accommodate for that one artist, think big, try and make as much of unit base and the experience accessible. If you think it's not possible we did it for Desperados, thanks to the tenacity and excellence of Ewan Marshall, on average there were at least 10 wheelchair users on set each day, the able-bodied crew were the minority! Where there is a will there is a way, we all ate lunch together as a team. On another production I spent weeks eating alone with a runner keeping me company while everyone else eats somewhere inaccessible.

One of the biggest concerns to location shooting and exterior shots is weather. A wheelchair user does not have the

same level of circulation in the lower half of their body and cold weather is going to be extremely challenging. Night shoots make this even worse. In my experience night time exterior shoots are gruelling, you just simply cannot keep warm, despite hand warmers and over coats. Keeping all cast and crew warm is a difficulty in some situations but for anyone with a disability it is essential they are catered for. For some disabilities a lower immune system can be a problem, some drugs taken for health reasons have a side effect of lowering immune systems, so they are going to catch a cold quicker and have more health issues when facing the elements for hours at a time. You need hand warmers, hot water bottles, places to sit out of the wind and rain. With the added problem of rain, it's worth noting that wheelchair seats take a while to dry and are hard to keep covered out of the rain. While an abled-bodied artist can wear a big coat, a disabled artist is sitting down on a seat that will become water logged. Spending up to 12 hours a day filming outside in the winter months is extremely challenging to anyone. This is one occasion where having a disability really does put you at a disadvantage. With planning and consideration, you can minimise the effect of extreme conditions. Snow is the worst of all elements as wheelchair wheels do not turn in the snow, even getting into work can be nearly impossible. I was actually pushed from my car to the studio one day while filming EastEnders by a fellow cast member who will remain nameless, we both had a good laugh as the snow was so thick they were dragging me like a sleigh.

On rainy days please be aware that there is a saying for wheelchair users "what goes around comes around" and mud on the bottom of a wheel will inevitably end up on the clothes of your artist. Costume need to ensure overcoats are available

and runners need to minimise distances to aid the mobility of the artist and protect costume.

On the subject of immune system, it is possible your artist may have medication or procedures they self-administer daily. Good hygiene is essential, especially in any disabled toilet. If you are filming in some dusty abandoned building, please try and keep the disabled artist's area as clean as possible. Conducting any daily medical routine in unsanitary environments can quickly lead to infection.

In terms of transport please don't assume that you need to hire a massive medical truck that normally does hospital transfers. I don't have one of those in my garage, a car will normally work just fine, only less ambulant electric wheelchair users need wheelchair accessible transport. It's an expense that you might not need, check with the artist before ordering a bus.

On set if normal health and safety rules are being followed things should be ok i.e. wires covered with rubber mats. On set it is advisable that the 1st AD be responsible for the safety of disabled artists from the moment they step on as they legally are responsible. Make your production team aware that Kino lights and equipment might have to be moved to allow a disabled person to step on. Inform your runners that calls to set must allow greater travelling time if needed. Appointing a runner to each disabled artist is a good practice. Although I have had one that would not leave my side, "I was told to keep an eye on you" he said, he actually chased me, he was very quick and I couldn't even sneak off for a quick cup of tea without him finding me. He was just doing his job which I understand, but no other cast member was under 24/7 supervision and even when I told him I was okay and didn't

need anything he still would not leave. It got to the point I had to ask the 2nd AD to tell him to give me a little more space and not take his instruction so literally. With respectful barriers established I actually ended up having a good laugh with him. As an adult you don't want to be treated like a child actor being chaperoned when we say we are fine, we are fine, you just need to know who to ask if you need something.

The other fear of employing a disabled artist is that they will be attending hospital all the time. Well, in all my years acting and working with various disabled artists I have never known any have a day off for illness. I can only recall myself having two paracetamols for a headache once and a slight raised temperature. Although I can remember being called in on a day off to film as a non-disabled actor had gone off sick and they were pulling a scene forward. It's important to remember that we all get sick occasionally and these things do happen. It is not something that should affect your production any more than any other artist.

Post Production

ADR can be a problem as most suites in London are in Soho and it is a lottery on where is accessible. There are some good ones but be aware before you book your ADR suite that it isn't in a basement. As an extra point be sure to take a few minutes and record some clean sounds of the wheelchair rolling and other wheelchair related sounds as this might help in the edit.

PR and Film Festivals also have to be considered. I absolutely love Edinburgh Film Festival and although the city is all cobbles and hills the organisers fall over themselves to help. By now you have worked with this artist and should have

a good idea of needs for attending any events. For artists based outside London it's worth noting how long it can take to get into town. If you book a press interview for 9am in east London be aware that some parts of town have no accessible tubes near them. Be kind and check times and travel arrangements before getting someone to get up at 4am take a train then a tube then wheel for 2 miles in rush hour. Rush hour on the tube in a wheelchair is just not pretty.

You're the Executive Producer/Producer, if you talk to your disabled artist and ensure these simple considerations are met then you truly can create an environment that gives a disabled performer a chance to give their greatest performance. If it has all worked the disabled artist will be as keen as you to sell this project and engaging them in the release and really celebrating the diversity of the project is your reward.

"All the worlds a stage, and both have bad wheelchair access..."

Casting Director/Agents

This is most certainly one of the most interesting areas of disability representation. There is a feeling that it is casting directors that don't want to cast disabled artists. I politely disagree, by the time a script reaches a casting director it is too late, a disabled character should have been considered much earlier and there is only so much power a casting director has to alter this. I have seen countless number of casting directors face strong questioning at events and they seem to take the majority of the flack for the situation. We have to remember they are one small part of a large value chain, albeit a very important part, but it is not fair to rest the full blame for any problems with them. That being said let's look at the role that casting directors and agents can play in increasing disability representation.

These two go hand in hand and it's a case of supply and demand. Agents are for the most part interested in one thing; can they sell you as an artist? If an agent is getting ten requests a day from spotlight for disabled artists and has nobody on their books who is disabled, then they soon will do. If the requests don't come through, then they are less likely to take somebody on.

Before we look at casting I was keen to understand this all better from an agents' perspective. I have been with my agents Emma Bloomfield and Barnaby Welsh at Bloomfields Welch for my entire career. When I first met Emma she was keen to discuss how we could work together. I was completely clueless about the entire industry and the idea of having someone to guide me was more than welcome. Emma and Barnaby's

agency is a mainstream agency and they represent a variety of performers from leading West End artists to leading names in TV and Film. I took a moment to ask Emma about the last ten years as we were both shocked with how quickly the ten-year anniversary had rolled round. I asked Emma what attracted her almost a decade ago to representing a disabled client.

"To be honest we are attracted to clients on an individual case by case basis and I ask myself do I believe in this actor and do I think I could work with them and help get them work. David Proud was an exceptional young man both as an actor and as a person I would want to represent and work with. The fact that he is a disabled actor did not factor in the decision process- he was an actor I was excited by and wanted to represent."

Ok, so I have to admit this did make me smile as Emma is being very kind to me, however it's interesting that in her mind the disability was not an issue. Her decision was also not lead by a demand problem it was entirely about seeing a performance and wanting to represent that person. It was me she wanted to work with and that's all that mattered. With that in mind I wanted to know if she had approached things differently with me. I was fascinated to find out as I never see it from Emma and Barnaby's point of view, I only ever get that call for an audition, they do a lot of work behind the scenes so is it different?

"My approach with David is exactly the same as with any other client it's about casting the net out as wide as possible and anything that might be right for him and within his comfort zone we would go for. For example David auditioned for an American role for the Donmar Warehouse. Although David

isn't Native American he was up for giving it a go and got excellent feedback from the Casting Director."

Very interesting as looking back I can see a big variety of parts I have been up for and I would agree they have cast that net wide, I have pushed myself as an artist to maximise the roles I might be considered for. I have to say that with the support and help of both Emma and Barnaby I have achieved above and beyond what I hoped too when I first entered this industry. However, the number of roles for disabled artists does fluctuate and some years have been hard. There have been a few examples of non-disabled parts being opened up for disabled artists and I wondered if Emma thought that casting directors where becoming more open to this suggestion.

"I think the BBC are particularly good and being open to this and as a public service provider have a remit do to this However I do feel very frustrated that disabled actors are not more widely represented in the industry and in the number of roles available- there should be many more to reflect society as a whole."

I think this is a frustration that Emma and I have both shared over the years and it will resonate with all disabled actors.

What I love about Emma and Barnaby is that they never represent people that are too similar, in such they don't like the idea of two of their clients competing for the same role. I think that's lovely, it shows that they are committed to the artists they represent. I know a great number of agencies are like this and it makes sense. As an actor you want to feel like you are the only client and Emma and Barnaby do that, no matter how busy they are. For disabled artists this level of support and

commitment is priceless. The idea of an agent meets with disability well, someone who can learn your needs and communicate them to the industry to maximise your potential. So with that in mind I asked Emma if increasing the demand for disabled artists would encourage more agencies to represent more disabled clients.

"I think so, Agencies are looking for clients they can place as easily and frequently as possible. If there were more parts out there for Disabled Actors it would be far easier for them to gain representation."

For agents, my advice is to take the plunge, take someone on and really sell them. Set them up with general meetings and use your power and influence to really make a difference. Most artists will be happy with a probation period of 6 months to a year to see how it goes. You have nothing to lose and everything to gain.

With this in mind lets now look at the work of casting directors.

The main priority for casting directors is to find the artist who can bring the part to life and present them to the director/producer. Sadly, currently unless the script says "wheelchair user", "amputee" or any other disability rarely will a disabled person get to read for a part (Disclaimer: During writing this book I am now hearing of more open style casting in 2016 at Channel 4, hopefully a trend that continues). This is not the fault of a casting director, they are only trying to do a good job and meet the requirements the director has asked for. They are trying to do a good job to hopefully secure that

directors next project, they can only go so far in offering some alternative suggestions.

In the last ten years we have seen a change in the use of disabled artists and it is now commonly known that using a non-disabled artist to play a disabled role is not good, although it does still happen. Casting is a time driven task and there is a limited time to be able to find authenticity. If a casting department has auditioned every known disabled artist and still not found someone right for the part they have no choice but to cast a non-disabled person, a point that links back to the original notion of needing far more artists, and a bigger pool of talent.

For casting directors there are a multitude of different directories available featuring disabled artists and spotlight themselves hold good records. Looking for new talent is difficult as if someone is not on these directories it is harder to reach them. It is worth advertising on charities websites, wheelchair sporting websites and other disability clubs, many disabled magazines now have presence on twitter and can announce casting calls.

If you are running a "find new talent" scheme and are considering applications, please bear in mind the very people you are looking for. Some may have extreme talent but be unable to submit fantastic written applications due to their disability. Consider the formats of any forms asked to complete including large fonts for the visually impaired or possible different colour paper for people with dyslexia.

There are a few very good venues to hold auditions in London, one of which is The Actors Centre on Tower Street.

When holding auditions please consider accessibility for your artists. Transport for disabled people can be tricky at times and unforeseen events do occur, please be tolerant with any late arrivals. TFL are making Tottenham Court road station wheelchair accessible but until then Green Park is the nearest to Soho, it's a trek in a wheelchair. Your actor might arrive out of breath and tired. I am always thankful to be offered a glass of water on arrival. Think about holding castings in places with car parks. The more you think about how someone could get there it makes a huge difference.

It might seem obvious but please no steps, I went for an audition for a channel that will remain nameless and faced two massive steps on arrival, no ramp. It's just rude, people are taking time to come in at their own expense, they shouldn't have to suffer indignity on arrival. I know most actors will jump through hoops for a part but don't actually physically make them.

There are many great casting directors in London, but when I was trying to think of casting directors with a benchmark approach to casting disabled artists Sarah Hughes leaped to mind. I read for Sarah in my second audition ever, even before I signed with Emma. Sarah was so welcoming she even followed up the audition with a list of agents to approach for possible representation. This was almost ten years ago but I have never forgotten the lovely supportive gesture. Since then I have regularly auditioned for Sarah and even been part of a casting team with her for a project. Sarah is remarkable at remembering people and faces and a fountain of knowledge. I was thrilled that she agreed to chat about disability representation for this book. As a casting director with

experience of casting disabled actors I asked her what attracted her to casting these roles?

I have a firm belief that what we see on screen and stage should reflect the reality and diversity of modern Britain, which therefore inevitably should mean including disabled actors amongst the non-disabled actors we see in productions. I believe that casting directors, directors and producers have a responsibility to include actors with disabilities in their conversations about casting all the roles they are working on.

How beautifully put, it is simply about being representative. With that as Sarah's approach to casting I wanted to know if she had found it difficult to find disabled talent for the industry?

Obviously I would like it if there were more actors with disabilities working in the industry but I know that it is really challenging (a) to get training and representation and (b) for a disabled person who would like to become an actor to believe that there are strong possibilities of sustaining a career as an actor as there are so few people with disabilities who currently manage to sustain a career - lack of powerful positive "role models" is quite an issue I think! but things are progressing, even if slowly.

Sarah mentions a lack of sustainability, a role model, and barriers to training and representation as factors working against disabled artists. I couldn't agree more; these are big issues and need to be addressed in order to increase the number of disabled artists in the industry.

With a small amount of disabled parts, I was keen to ask Sarah about placing disabled artists in non-disabled roles. Could this help build careers and experience?

In the longer term (and I agree this is not fully happening yet!) I would rather not see things in terms of disabled and non-disabled roles. Obviously some parts are very physically specific, and that will never change, but there is no reason why a teacher, a banker, a psychiatrist etc should not be played by someone with a physical or sensory disability. We need to see more of this and to demand more from our tv and theatre companies.

You can see why I admire Sarah's work so much, it would be great to eradicate disabled and non-disabled roles. It's a fresh idea that someday roles are open to all, within reason.

My last question to Sarah is probably not one you would expect. What I find frustrating as a disabled artist are artists that are not doing all they can to make themselves more employable. I believe that although the industry is hard it is every artists responsibility to do what they can to be better. Not to rely on disability to get them in the room, or feel like the industry owes them a chance. My last question to Sarah was to ask what disabled artists could do to become a stronger choice in casting?

Apply to the Drama UK drama schools for training and keep applying, don't be put off! These schools have a responsibility to start working harder in adapting their teaching methods, their timetables and their spaces so that non-disabled and disabled students can train together. And get together with other people, non-disabled and disabled, to

generate work whether filmed or on stage, so that people can't avoid you!

Great advice and especially the part about generating your own work, being proactive not only makes you more employable but it is also a state of mind. Begin to express yourself in every way you can, it will make you a stronger artist and a stronger person.

The utopian casting room is a room full of, non-disabled and disabled people competing for the same roles. Just because a script does not say "disability "does not mean you shouldn't look to invite a disabled actor in to read for the part, what have you got to lose? As an actor it's all about meeting casting agents, if you know who we are we have a greater chance of working, either on the production you are on at the moment or one you will cast in the future. We have heard from an agent and a casting director and can start to see how these are interdependent, it is not fair that any of the blame for lack of diversity rests with casting and we can't expect agents to take on clients when there are no roles to be filled. Casting directors are working for a director, who has the final say creatively on set, so let's look how disability may alter production for a director.

"There's no business like show business, and for disabled artists there's no business in show business..."

Directors, Assistant Directors and DOP's

As a director, you will have an artistic vision of what you expect to see. You will need to work very closely with a disabled artist to make sure the shots you have planned are physically achievable. You will also need to consider restraints on any outdoor shoots, what a person in a wheelchair can do on tarmac is different to what they can do on grass. What they can do in the dry can be different to wet slippery conditions when a wheelchair has less grip. In ice and snow working outdoors can be almost impossible. The more you know your artist, the more you can plan ahead. Rehearsal is strongly advised on all productions, not because of performance but more as a tool to be able to get to know each other and develop good communication.

Avoid the temptation of slipping into stereotypes that aren't in the script when blocking scenes i.e. having another artist pushing a disabled persons chair. Similarly, if a disabled artist raises a point about the script that just would not factually happen bare it in mind. You will have to decide if the amendment fits in with the overall piece. For example;

In an ongoing drama you are shooting a scene where an amputee is scripted to be lifted into a car. The series has been written by one of many writers who are not available for consultation. The disabled artist advises that they have never been lifted into a car in their life and does not know anyone who ever would be lifted into a car as an amputee. It is your choice to overrule the writer seeing it as an oversight or lack of

research or go with what is written and risk having people write in to complain about a factual mistake.

As a director situations like this occur often, and this is why use of a disabled artist is vital. There is a balance between a disabled artists own experience and the journey of their character. As long as artistically the journey of the character is intact I would always recommend listening to the advice of the artist. However, if you have time I would raise this as an opening point to the artist to invite any discussion like that before you reach the point of filming. Consultation is vital to completing all the scenes on time and with the correct content.

Imagine a tracking shot following a person in a wheelchair on a low level and how cinematic and beautiful the fluidity of the movement of the artist and camera would be.

Working with artists in wheelchairs can be almost like choreography and a dance between the camera and the artist. It adds an additional dimension to filming as you are working with different angles and different shots, this can lead to a really unique feel. It can be great to top and tail a scene with a pan up or down from a wheelchair user. It creates movement and transitions well in the edit.

DOP's will have an interesting time when first working with a disabled artist amending all those angles. However, the greatest trick and one used many times especially on low budget pieces is to use a wheelchair. It is a cheap way of creating tracking shots that are at the correct height. The site of a DOP in a wheelchair being pushed by a camera assistant is a common one on productions I have been involved in, especially for POV shots. Low legs will need to be used and

depending on budget steady cam can produce amazing results when circling wheelchair users. The new small Go Pro Cameras can attach to the chair and create great POV shots. Lighting can prove to be a little tricky and requires thought due to size of equipment, legs of the stands protrude and while easy to step over, they are harder to avoid with wheels. Sandbags make easier marks as wheelchairs role onto them and it can be easier than seeing tapped marks from a seated position. Be aware however that it is incredibly easy to be off your mark when wheeling a wheelchair as just a fraction of an inch can make a big difference. Also as an artist it is not easy to shift your weight to find the lens when you are sat down.

Assistant directors have a lot of contact with artists so they have the ability to spot problems. Asking for help can sometimes not come easy to disabled people or any of us really. If you notice that a disabled artist appears to be struggling with something asking them about it is not forbidden. From own experience sometimes when you are focussed on a script or role you don't realise that asking for a little help with something around unit base or on set could help you deliver a better more energetic performance. A good second AD can have that relationship to tell you that your looking a little tired and maybe need to take it easy. If fatigue is spotted schedules and call times can be altered and the disabled artist will appreciate the thought about their welfare, coming in slightly later one morning to rest a little can help prevent illness.

One point to consider is that an artist in a wheelchair in a large crowd of people can be lost. It is very easy for people standing to mask someone sitting down. The easiest way to overcome this is to use the disabled person to wipe through

frame. Make them the focus of the shot and you might escape having to do another set up to catch the fact that they are there. It is very soul destroying to be in a scene but not in it. A disabled artist will soon get very upset if they realise that the lens can't see them all the time.

There are a few great examples of how authentic portrays have been successfully delivered to our screens. CBBC's *Desperados,* and BBC's *Best of Men* are two such examples. Let's look at both and the Directors that were responsible for delivering them to our screens.

Our first project to look at is Desperados, a ten part CBBC drama featuring an entire cast of disabled actors, following the story of Charlie, a teenager dealing with a spinal injury. Our second project to look at is Best of Men, a single Drama for BBC Two which told the story of Dr Ludwig Guttmann and how his pioneering work during the Second World War led to the creation of the Paralympic games. Two programmes aimed a different audience but each one pushed the boundaries of our industry. In this more in depth look we will also hear from Director Paul Wroblewski (Director of Desperados) and Tim Whitby (Director of Best of Men).

Desperados, produced by the exceptional talent of Ewan Marshall, was a bright vibrant journey into the disabled world for children. Charlie, a young teenager with an interest in football suffers an accident on the pitch and is then thrown into dealing with a spinal injury. As part of this rehabilitation he is invited along to join the Desperados, a group of wheelchair basketball players. Penned by Paul Smith this was a groundbreaking show and Ewan's efforts for authenticity went to new lengths, even in casting non-actors in lead roles. One particular non-actor even managed to secure the lead role of Charlie, and

that person was me. Having played wheelchair basketball since I was 11 I was no stranger to the game. It was actually my basketball coach who informed me of the auditions and the fact "the BBC want to audition wheelchair basketball people". At the age of 21, having given up hope of acting and leaving it at A level, I had joined the real world and was working for the Department of Work and Pension. Along I went to the auditions and the rest is history. The audition process took many months and I had met Paul Smith at one of the earliest auditions. What never occurred to me until much later is that I had seen him at various wheelchair basketball events that year, sitting quietly making notes. Paul's level of research and Ewan's drive for authenticity lead to a very unique show. The disabled cast was almost entirely made up of non-actors who were disabled. Once the show was cast private tuition of acting classes helped to get everyone ready for filming and we also had access on set to an acting coach.

This programme was very well received by the industry and to this day I am cast in new shows on the strength of it. Only last year I asked "did you hear about me because of EastEnders?" to get the reply from a director "no, we had seen you in Desperados". It goes to show that some programmes really do get noticed and so they should.

Paul Wrobsleski directed the second block of Desperados, Paul, a Bafta winning director has directed shows such as EastEnders, Emmerdale, Casualty and Holby City to name a few. On set we had a tradition that every Friday was "fancy dress Friday", this was due to our utterly brilliant second AD Diane keeping us all entertained. I seem to recall the first time I met Paul we were both in Roman toga's, what a brilliant way to start a working relationship. Paul's episodes were the hardest

in terms of emotion, and he guided the cast through very tough scenes with such charm and energy that it was very emotional when filming drew to an end. I caught up with Paul to ask him how he felt about the experience of filming and his thoughts on the use of authentic disabled artists.

"Nearly a year before Desperados was made, I had read an article in Broadcast magazine about a CBBC commission for a new drama based on the fortunes of a wheelchair basketball team. The article went on to describe that the cast would be drawn from a group of young adults who were disabled but who would not necessarily have any acting experience. By that stage in my career I had directed a number of challenging children's dramas for the BBC, including Jeopardy, a drama set in the Australian rainforest, billed as "Lord of the flies meets the Blair Witch Project". Making Jeopardy was a huge challenge, as I encouraged the professional cast to immerse themselves in their stories and characters and to shut out the "glamour" of being on the other side of the world. We shunned the use of tear sticks used to create spontaneous crying with no emotional effort, instead I would tell the actors stories based on what I knew about their real lives, in order to achieve genuine emotion. This turned out to be quite a successful method of inducing tears, so much so, that I had adult members of the cast, when called upon to be crying, come to me and ask " will you tell me a story?!".

I came home from two stints on Jeopardy feeling that I had got back from that experience, as much as I had put in.

Little did I know or expect that after working on Desperados that I would get back far much more than I put in, or certainly, that what it felt like.

First I had to get myself seen by the makers of Desperados, this was a show I had to direct.

Nearly a year later, my agent asked me to attend an interview with Ewan Marshall, the Producer of a new show about a wheelchair basketball team. This was it, my nervous energy went into overdrive. I read the scripts that I had been sent, made copious notes. Read them again, and made even more notes, I couldn't blow the chance to Direct this show.

I had the interview with the most charming and likeable Ewan, my agent rang me and told me that I had got "the gig". I was over the moon.

My first day on set, I was unusually quite nervous, which I put down to wanting to make a good impression, but I realised it was more than that. Until that day I had never been in a room with a group of disabled teenagers. The cast gathered round me in the middle of the basketball court. Nervously I said " let's read the scene we are about to film, talk about it, then we will put it on its feet" "put it on its feet?!!" Paul, what in Gods name have you just said? I remember wanting the ground to swallow me up and spit me out somewhere far away from there, but it didn't. What did happen, was the beginning of a wonderful relationship with every member of that cast. They laughed at me, a barrier I had unconsciously constructed was swiftly pulled down by the cast. Needless to say, none of them missed an opportunity to rip the piss out of me from that point on.

What I didn't bank on, was a tireless energy, a drive to get the scenes, the performances as spot on as possible. Their energy left me exhausted. I honestly felt that the cast pulled me through the experience of Directing Desperados and they did this unconsciously, constantly wanting to be better and better. The most amazing thing I discovered during the filming, was how expressive the cast could make their wheelchairs. It sounds odd, but just the way they could enter a room, come to

a halt, turn on a sixpence, all added a phenomenal layer of character that was incredible.

For me the most amazing thing was their honesty and truthfulness, both in their performances and in their own being as young adults. There was never a hint of the one-up-manship that is often seen in young professional actors. They were all generous to their fellow actors, giving as good a performance as they could, for whoever was on camera.

So, it has to be said, I came away from Directing Desperados having been taught more about myself, I shamefully got more than I gave, or at least it felt like that. Why? Because the young cast of Desperados knew what honesty was, they knew what generosity was, they knew what truth was. It was a two way journey, but they took me further than I took them

I can honestly say that Directing was never as fulfilling or indeed fun after that.

When the final days filming came around, the cast gathered round me for the final scene. "Any questions?" I asked. A hand went up, "Paul, do you think there will be a series 2?"
"OF COURSE " I replied, "this series has got legs ""

Despite the success of the show and the critical acclaim, awards it won, Desperados was not renewed for series two. We all knew on this project that we were working on something very special indeed.

Hopefully Paul's very insightful testimonial has given a little taster of the benefits of working with a disabled cast, of which most were disabled children. It appears Desperados did not falter under the fear of getting it wrong or offending.

Production worked together to overcome every obstacle and the result was a heartfelt, quality CBBC Drama. With a majority cast of unknown disabled child actors, Ewan and Paul were incredibly smart by casting known actors as the parents. This wealth of experience rubbed off on all of the first-time actors. My father in the show, Johnny Guy Lewis was a pleasure to work with for three months and to this day I still remember the wise words he told me.

Now let's look at a project aimed at a slightly older audience.

Tim Whitby, a prolific and exceptionally talented Producer and Director, directed Best of Men for BBC Two. Tim's work spans some of our nation's greatest titles including Bramwell, Cold feet, Shameless and The Village. It is safe to say that this impressive list did make me slightly nervous ahead of my audition for Best of Men, however Tim is one of the most friendly and approachable directors I have ever had the pleasure of working with. Whitby Davison produced Best of Men, it was produced by Harriet Davison, directed by Tim Whitby and it was written by one of my favourite writers in the world, the adorable Lucy Gannon.

Tim and Harriet's work on Best of Men hit upon a formula that may be the answer to the question of increasing disability representation on screen.

Best of Men was a single drama/TV movie, it starred Eddie Marsan as Dr Guttmann and featured Rob Brydon as a loveable Second World War veteran, it also featured a young George MacKay as the lead. Packaged around these very accomplished and experienced actors Tim ensured that authentic actors with

disabilities were given as many parts as possible, of which I was lucky enough to be one of them. What this did is allow the project to retain its commercial appeal, with notable actors making the show a viable project, but being smart by weaving in as much authenticity as possible. A project like this must have generated some challenges, I asked Tim what those were and how he overcame them?

I don't think there are particular challenges except the obvious and not very significant practical ones - is there wheelchair access (if relevant) are there adequate bathrooms, costume facilities nearby etc. As a director you are usually up against time so there can be small issues here but there are always issues when filming of one kind or another.

But in truth, Best of Men was about wheelchair dependent characters so there weren't scenes written on top of a mountainside or at a disco, Aside from practicalities, disabled actors can be exactly as insecure, brilliant, exhausting, challenging and delightful as any actor.

Clearly a disabled character functions differently - whether movement or speech or in some other way - and that requires the director to think imaginatively about how that character will behave during a scene. But that is truly no different to thinking through how any character will act and then how best to capture that on film.

Encouraging words from Tim to show that the amount of challenges that are different to any other character are very few. It is more a case of trying to understand the differences of the character and its portrayal.

With that in mind I asked Tim what were the potential benefits to using authentically disabled artists?

It forces you to think freshly. Drama is all about empathy, imagining what it's like to be someone else and selfishly, the whole experience was challenging and rewarding. More broadly Best of Men was about Ludwig Guttman's pioneering work with patients with spinal injuries. Young men written off because there was no way cure them and therefore they weren't seen as equal human beings. Working with people who can be the victims of prejudice is eye opening.

It seems Tim gained a lot from the experience of Best of Men and I wondered if this had encouraged him to use more disabled artists in the future?

Yes. This was a drama specifically about disability and therefore it was obvious that casting disabled actors would be important. The bigger challenge is to consider disabled actors for a broad range of parts whether or not the script demands it. This is practically often very difficult when casting happens so close to production and casting a disabled performer would almost certainly require some script revision. I don't necessarily mean to make disability the subject of the script or the character but quite possibly to change action. There is no avoiding the fact that if the disability hasn't been factored in from the start of planning, it can be difficult and potentially expense to accommodate change.

It is interesting that Tim's thoughts do match the words of other people in this book, if disability is not stated in the script time restraints and the amount of amendments needed can be a barrier to inclusion. It seems that the overwhelming response in

this book is urging for disability to be considered as early in the process and possible and that the biggest barrier to disability is not allowing your team time to plan and amend scripts in order to make the most of a potential portrayal of disability.

My last question was to ask Tim what advice he would share with fellow directors in working with disabled artists?

Two things – advance planning and frankness.
Advance planning is really about thinking through issues right across production and making sure everyone knows what issues there might be.
Frankness. It's obvious but disabled actors are very familiar with the effect of their disability. And they will know what they can and cannot do, what they might need. Don't assume a person in a wheelchair can't walk at all. Ask. Be open and be specific about what you are planning to achieve and how.

The formula that Tim and Harriet hit on with this drama worked, Best of Men was met by critical acclaim and boasted a record audience satisfaction figure for BBC Two. It was quickly repeated numerous times and far exceeded expectation. It is a critical film not only for the content but the way it was put together. Delivering such drama and emotion in an authentic way that honoured the memory of Dr Guttman.

Both of Paul and Tim showed outstanding leadership in these projects and a lot can be learnt by the success. To any new actor entering the industry I hope you have the pleasure of working with them both in your career. In the next chapter we have a look at some tips that may help any new disabled actor should they get that call. For anyone else it is worth reading the

next section to understand how the approach of a disabled artist may be different.

"The great thing about being a disabled actor is sitting in someone else' wheels, following in their tracks…"

New Actors

Your journey as an actor begins here, please take a moment to ask yourself this question, why do I want to be an actor? It is very important that you can answer this and know your own motivation. As every actor will tell you it is one of the hardest professions to work in. At any time only 2% of all actors are employed. The competition is fierce, the chances of succeeding to a level you want is small, and at the start of your career you will be earning very little, most actors earn an annual salary of under £20,000. Having said that, if the passion for acting you have is big enough none of these will stop you. In this book we will break acting into logical parts and hopefully give you some food for thought. We will also start to really create a methodology for disability acting, a frame work that when applied to your craft can help to bridge that gap between where you are at now and where the industry needs you to be. Whatever level you are at it's important to be aware and honest to yourself about your skills, as an actor you never stop learning. What you do and how motivated you are is up to you. It is worth bearing in mind that you will be competing for roles with people who are not only very talented but also very motivated. Be better, be better, be better! On that note, who is your competition? Do you see other disabled artists as competition or are you looking further, aiming to be in a casting waiting room surrounded by non-disabled actors? In either of these situations you are going to want to be the best you can be, so here are some pointers that might help.

The Basics

Every Actor has to consider what their act is. How old are you? Are you male or female? Do you look sporty? Can you sing? Could you play a mother or father? Could you play a character at school? As you age so does your act. Due to this you will inevitably experience highs and lows as you might not make a great teenager but as you age you might make an excellent parent. Enjoy the good times when they come and try and prepare for the tough times. Take a moment to consider what your act is, as you will need to describe the following.

- Minimum and maximum age you could play.
- Hair Colour
- Eye Colour
- Ethnicity
- Voice type
- Type of Disability
- Languages you can speak
- Any other noticeable qualities
- Any other notable skills

An old acting term states "play to your strengths". This is the way in which you will probably enter the industry. The jobs you are initially competing for are ones looking for disabled people, as this is your niche. Although after enough experience like all actors you should look to break your mould. So considering this, how do you compete for these roles. What do you need to get started?

As an actor who has been in the industry for many years you may have collected the following;

- Accountant
- Acting agent
- Publicist
- Photographer
- Show reel editor
- Web designer

When you are just starting out firstly you will need to find a good photographer to take a nice headshot photo. These can be found by looking at a copy of the book "contact's" available to purchase by spotlight.com. It will also tell you the rules of the photo you need. Once you have your head shot you will need to approach an agent. This in itself can be very hard. You have to sell yourself to them. The normal procedure is to send them your nice new headshot photo and a letter explaining experience and your ambitions. Once you get representation and begin to work you will need a good accountant. Acting is a self-employed job and most of the work you will do will need to have tax paid on it. Don't panic, Tax normally scares most actors and ask anyone about doing accounts and they will all roll their eyes. A good accountant can really take the stress out of this.

Once you have enough material you will need to find an editor to create a show reel. This can be incredibly good at showing potential employers what you are capable of. If you have the chance to make a website for people to keep up to date with what you are doing it's worth it. Most websites can be linked to twitter and with very little expense you can really get your face out there and get yourself a little following. This is, as explained earlier, down to how motivated you are, acting

is a very sociable job and networking plays a huge part in being considered for jobs.

Social media is growing in importance and it can be a handy tool in self marketing at the earlier part of your career and also engaging audience once you have appeared in a few projects. One word of advice is being careful with this; social media can be a friend and an enemy for two reasons. One, what you post and how you speak to industry members can hinder job chances, so just be you and don't try too hard to get noticed, don't annoy people thinking it will bring you work. Two, be careful of engaging your audience too much, especially when work brings fame, beyond thanking people for a compliment it is dangerous to continue dialogue. Be polite and professional and think before posting any work related rants or funny quotes that might offend people. Your online profile is a representation of you and your professionalism.

One thing that happens a lot in my experience, probably due to the fact occasionally I cast films and plays I am working on, new artists ask to meet up with me to chat. The reason is clear they are asking for advice to help their career, or consideration for future roles, which I am always keen to help with however a one on one meeting is not the most appropriate of situations. Where possible instead of cold calling industry professionals and asking them to "have coffee" or "meet up" in a hope it furthers your career instead just tell them where they can access your work. For example, "My play is being shown at the Bush Theatre Wednesday, I admire your work and would love for you to see it..." or "I very much enjoyed playing ____ in ____ if you have five minutes you can see it by clicking on this link. Many thanks. Xx". You must remember the casting directors, directors, producers you are trying to engage in

conversation on social media have families and your career ambitions aside it isn't always appropriate to be meeting ambitious artists for coffee. If you want advice it is best to attend an event they are advertising, or research and attend larger networking events designed to allow this connection in a secure environment. Networking is an important part of being an artist, but there is a right way and a wrong way of achieving it.

Back to the acting part and by now you are already screaming "but how do I get work if I don't have an agent", try casting call pro and various other sites that link you with film makers, offer to work for expenses and a copy of the film, go give a day to a production and after you have done a few you will have footage for a show-reel, it's not an overnight solution but it can work.

When considering agents please never pay to join an agency. A good agent will only take a commission from the work they get you. You may have some initial costs they ask you to cover, such as providing prints of headshots for them to send out, etc. You are responsible for all these costs, but they shouldn't charge you a fee to be with them. For those completely new to acting it is worth knowing what average fees are. For commercials it is normally 20%, for TV and Film it is 15% and for Theatre it is 10%. The reason for this is that commercials are normally very well paid and a "buy out" – no repeat fee's, Film and TV works on a smaller pay but has an element of repeat payments/net profit and Theatre is mostly the lowest pay. You can see that the industry standard presents a fair system for each area. Some agencies have different rates, an agency that charges a flat 20% for everything is a little harsh

but they are out there. You will find if an agent wants you bad enough they may well negotiate.

It's worth you gaining a basic understanding of all of this and all of these things can be constantly upgraded and worked on but will make you look and feel like a professional artist. If you do not take yourself seriously as a performer don't expect a casting director too. When you break your niche and compete with non-disabled actors they will have all of these and a strong knowledge of how it all works.

In terms of performance there are some things that a disabled artist will need to consider. The first is that you may be asked to portray a different disability. It is really important that as a disabled artist you have good understanding of most types of disability. One of the most fundamental of these as discussed is that there are disabilities people are born with and also acquired disabilities. It is important for you to understand the common psychological differences between the two as this can affect your characterisation. We touched on this earlier in the section on disability but it really is vitally important to you as an actor. If for example you character has recently had a car accident their acceptance of their body image is going to be far different to a character that has always had their disability. This part of acting requires you to be very honest with yourself about your own character, disability, and acceptance of it. Only then can you begin to analyse other people. You need to be able to show a producer and casting director that you have the insight into disability as a whole and not just specifically the disability you have.

Vocal projection can be a very big problem when sat down, due to a restricted diaphragm. On a film set you will be

constantly reminded by directors about increasing your "levels". By this they mean that your sound is not projecting enough to reach the microphone. On some sets you may have background music or other sound effects added in post-production so it is important to be able to project your voice even from a sitting position. There are a lot of qualified vocal coaches who can help you develop techniques for increasing you level. A few simple tips are not to drink ice cold water on set as it isn't good for your vocal chords and also try and exercise your mouth as much as you can before a scene. It may look strange making weird facial expressions but if it helps you to be able to get the lines out and be heard no one will mind. Try and research some breathing exercises and consider the way in which you are using your diaphragm. If you struggle with clear diction, a really cool trick is to hold a wine cork in your teeth and try and speak your lines. What this does is get the rest of your mouth moving, it will sound horrendous, you will dribble, but when you remove the cork you will find your mouth muscles are working harder. Remember the phrase "a cork in the mouth improves diction". Hmmm imagine if you said that line with bad diction eh? Please don't put the cork far into your mouth, the tip of your teeth is fine and I don't want people choking on them, I except no liability if you do. This trick can be especially useful if you are trying to perfect an accent as with accents you are changing the way you use your mouth and tongue to create sound.

If you have the ability, never throw away any mobility aids. A different wheelchair can be an entirely different look. Directors do like options and being able to offer them an alternative look can make you look very professional. Do a Robert Deniro and turn up to the audition in the look they want. Famously Robert Deniro had a massive wardrobe in his

Tribeca home and turned up to early auditions dressed in character. Be the disability they want! On the subject of wheelchairs, keep it clean guys, turning up to an audition with mud all over you isn't very professional. If you are like me your wheelchair is an extension of you so make it look good and maintain it.

Before we look at auditions and beyond let's touch on two big factors that really establish an actor as professional. These two are the actor's union Equity and the casting website Spotlight. When you register with Equity (entry requirements must be met), your name is protected. If you tried to register with Equity as David Proud, you will be told you cannot, as I have already taken that name as my professional name. It makes sense as choosing Johnny Depp as a stage name would just make you look unprofessional, be you, but be prepared to have to change your name if there is already an actor with yours. Being a member of Equity just makes sense, check them out, along with protecting your name you are also personally insured against damages. If you are as clumsy as I am this is worth every penny. I once cut my hand on the set of EastEnders due to being clumsy and not looking where I am going. I could have knocked the set over and caused thousands of pounds in damage. Equity is worth it for peace of mind alone, let alone to support the values and work they do. You can pay for Equity in many ways and it really is something you don't want to cut costs on.

The other site you may not have heard of is Spotlight, this is an industry standard casting website. It isn't used in the sense that you can look for casting breakdowns, it is more of an internal communications platform which allows agents and casting directors to share mass information easily. If you meet

the entry requirements you will set up a profile, add a show reel and pictures and be able to share that profile easily by sending your unique view pin to anyone you wish to view it. When signing with any notable agency they will need to you have a spotlight page and it is up to you to maintain the cost of it annually. This will help them sell you and get you seen by the best casting directors in the country and it may seem like an expense that you would want to avoid but at the level you are aiming at it is essential.

Auditions

The dreaded audition. As an actor, you're going to attend a lot of these with a bit of luck. Some will be brilliant and you'll feel like you gave it your best, others will have you screaming all the way home. Time for some words of wisdom, imagine you are a casting director/director and you have sat all day in a small room and 40 people have come through the door. You want them to be what you are looking for as you can go home, the job is done. No casting director ever wants you to fail, you must understand that you could give a BAFTA award winning performance in an audition but if you are too old/young you won't get the part. All you can do is go in and give it your best. If you impress the casting director or director you may be considered for other roles. This does happen, not only do casting directors and directors talk to each other they may even write you in a different part. If you are given script to learn really be on top of it, most casting directors don't expect you to be off book, or word perfect but it shows if you have spent time being familiar with the script. If the film or show is based on a book, read the book. Sometimes we only get a few days' notice for an audition but the more you can prepare the better. When you know who you are seeing look them up online, never go

into a room not knowing who is in there. You should at least have researched the director, casting director and producer if known. It takes less than five minutes to Google people. You can find almost anything online, my point being that this is a very important part of preparation and being professional. Know who you are seeing, know your script and know that you are prepared.

On the day of the audition just relax, be yourself, be polite and enjoy the experience. Have fun with it, you are likely to be asked to do the same lines a few times and different ways and just give it your all. Your audition begins from the moment you get to the audition building and ends only when you leave. As well as looking at your acting ability they will be trying to work out if you are someone they would be able to work with and if you can deliver that performance on set. Don't worry about asking for specific requirements to do with disability. If you have been invited to audition they want to see you and will make sure your requirements are met if you explain what you need. Yes, you will have cringe worthy auditions, yes you will read for a part that you don't really want and you'll definitely read for a part you really want. Tackle them all in the same calm, prepared manner and let fate do the rest.

In time auditions will be as routine as going shopping. The aim is that so many casting directors and directors will know you that you will be invited to audition for things because they remember you, or even better, just offered the job, no audition.

It's also important to learn the industry you are working in. Who's who and what's happening. Be informed and use social media to follow industry press like Screen International and the Hollywood Reporter, read the Stage magazine. Beyond

keeping your ear to the ground research your industry, start a file on your computer entitled "casting directors" and pause the credits at the end of the shows you like to find out who casts them. The BBC will largely be the in-house casting team unless you are watching a show that has been created by a third party production company. Most casting directors are on twitter, follow them, I wouldn't advise spamming them or stalking them but as mentioned before keep an eye out for any casting calls they mention and events where you might be able to attend. UK based directors would be another good file to keep. Which directors are working on soaps? Which are working on period dramas'? Use IMDB to discover the links between people. I created a short film with a good friend of mine who is a phenomenal actor and producer. If you study IMDB you would find that we met on a film at the start of both of our careers. Getting a picture of the industry and the people in it will show you that it is pretty small, small enough to comprehend and understand. All of this work will help to understand the level of the people you are working with.

Now let's look at the differences with Theatre and Filming.

Theatre

This section is shorter than the filming section, and that's partly because the majority of my experience is on screen, but also because the world of Theatre can be hard in terms of access. We are blessed in the UK to have some of the most beautiful ornate old theatres in the world and I love them all, but they are so difficult for access. Entering the theatre via the stage door most of the time involves a step. The dressing rooms are normally in the back corridors behind the stage and little

steps lead you up and down. Stages are normally accessed by steps and will be badly lit during performances. Once you have made it onto stage, most have a rake. A rake (or slope) is an angle the stage is tilted towards the audience to make the stage more visible to the audience, the greater the rake, the greater the problem to wheelchair users. If you imagine taking your hands off the wheels at the back you will naturally roll to the front, just a little something to consider with stage work, turn to the side to avoid a roll. Sets can be big, clumsy and hard to navigate around. You have actors flying onstage and off, engineers and stage managers hiding in the wings. It does make you wonder why anyone on wheels would bother. I will tell you why… because it's the greatest feeling on earth playing to a packed house, feeling all those eyes on you, the glare of the lights, the man stifling a cough. You deliver that brilliant line and they laugh or cry, you finish, soaking in sweat, absolutely shattered, and as they applaud you, you know you have to do it all over again tomorrow. Unlike film the response is immediate, you come alive with the experience of it all and in the bar after the performance a man you have never met shakes your hand and says "well done".

What can we do to make this feeling of artistic joy accessible to everyone?

There is a massive push to try and make theatre accessible, and there are some more contemporary theatres that have better access. There is also a company called Graeae who specialise in disability theatre. They have put on some of the most ground breaking shows and, as the website says, they break down barriers. I'd go as far to say they smash down barriers. I can't praise them enough so go get in touch with them.

Where there is a will there is a way, and if you are right for the part then I honestly believe that any theatre company will go out of their way to accommodate any needs. Be prepared to compromise, theatre isn't well paid, it isn't going to get you seen by millions of people. It is however vital in our industry. I'd like to tell you a little story about a friend of mine, hugely talented guy who came out of a UK soap with high expectations, he was then unemployed for over a year. He was finally offered a lovely part in a show that would mark his west end debut and although he was struggling financially he took it, despite the long hours and low pay. He hasn't stopped working since. After the play came a TV offer from casting director who had seen him in the play, then another, then another. Casting directors and directors are going to the theatre every single night of the week. Even American casting directors are casting straight from the west end. This is about building a career and keeping your skills sharp. A small run in a good theatre show can secure jobs for you for years to come, so sometimes having to compromise and think outside the box about access issues is really worth it. My agent Emma has always said "David, it's a marathon not a sprint", and she is right. If we can get more disabled people "wheeling the boards" – I am starting that as a thing #wheelingtheboards – then we will see more disabled people on screen.

One rule of theatre that is great for us is that "there are no mistakes" if your crutches/wheelchair knock over something go with it as if it was meant to happen. This can really help with this unusual partnership of theatre and disability. Get to know your set; you will have to navigate it in the dark between scenes. You will have to navigate wires, curtains, set, cast members, and that rake all in the dark and all without talking or making a noise. They don't call acting an art for nothing.

The good thing about theatre is the amount of time you have to rehearse. Unlike filming, you will spend weeks bringing the production together. You have more time to discuss practical issues and really get to know your colleagues and environment. Use that time wisely and you can't go far wrong.

A final note is that theatre work is draining, your stamina will be tested to the extreme. The hours are exceptionally long and you will need to eat well, keep active and fit and don't get run down. Tours can last a long time and cover many miles. Even the most fit, healthy non-disabled actors experience fatigue in long theatre runs. Health problems can creep up on you fast and for those that drink, lay off the booze, no performances with a hangover. After show parties might be tempting but learn the phrase "oh not for me thank you". You will appreciate it the next day!

Filming

This section is a little larger and broken down into more sections. There are a lot of dynamics at play as with theatre your performance is a stage, filming demolishes that structure and puts you in the environment of the script. That, as you might think, can create some problems…

Pre-production

So you have a role and are about to start filming. Being an artist with a disability you will never just pitch up and do your thing. You will always have slightly more involvement making sure that everything is ok for you to be able to perform. As an

actor it is your job to make sure you work with production so that everything can run smoothly. Bear in mind that on each job if a director likes you he/she might use you again, treat every job as an audition for the next. Nobody likes a Diva so try and be as polite and as accommodating as you can. Be honest about your requirements, your performance is your main priority and if you're struggling with something it will suffer. A producer can get financial help for your requirements but they need to know what they are. You will likely get a call from a production assistant and then a second assistant director asking about what you might need. If you don't feel happy talking about something personal with them it's important that you do tell the producer, they will be able to filter the right information to them.

Be prepared to be called in for a costume fitting, this is fun, someone goes out and buys lots of things and you get to try them and reject what you don't want to wear. You get a chance to discuss how disability might affect costumes, be open with the costume designer, I haven't met a bad one yet. If you need duplicates of an item of clothing due to disability tell them, they won't mind. They will soon have you kitted out in the best outfit possible. This might be the first time you have ever visited the studio. If the show is already filming you will normally go to where they are and try some things on, if they haven't started you will go either to the production offices, or a costume facility. This might also be the first time you meet other cast members coming in for fittings. It's a great time, as you get to see things and meet people ahead of your first day. Once you put your costume on it will hit home that you actually got the part, it's yours, and now you get to film it!

Another day you might have is a table read. Don't be too nervous this is just to get everyone to sit in a room and read the scenes. Sometimes your main lead actors aren't available so not everyone is there. At one of my table reads three people had said they weren't available and I was asked to read three parts, I almost created different voices and slipped into some split personality mode, but it was fun. All the director wants to do is hear it. By hearing it they are able amend anything that doesn't fly off the page and add bits. It's great when you get to do one of these as you've just met your fellow cast members.

You may even have full rehearsal days if the director feels it's needed. These are great as the more you rehearse it all the better it will be. Enjoy these and really use the time to get comfortable in the skin of your character. They will likely try and "block" the scene, it's a chance to run through where the camera might be and how the scene will come together, a great time again to discuss any issues.

The first few days of production the crew and other cast will be more nervous than you, as they are trying to get to know you and also not say anything that isn't politically correct. It is really important that you try and put them at ease, a good relationship with crew can go a long way to a great performance. Please make sure you read the other parts of this book which detail the differences that they might be going through with a person with disability on set, see it from other perspectives. Be prepared with your lines, you are likely to be very nervous and be bombarded with lots of information and preparation can be vital. Be on your material, on time and concentrating.

Lastly, before we look at filming you will be sent a declaration of health form for insurance purposes. All film shoots are insured; they have to be legally. This is to ensure that if your leading actor breaks his leg midway through the shoot, you can claim for any expenses to get the film finished when it over runs the schedule. Don't be too scared of these, I have not had any query on any I have ever filled out and I am a complex bean, but it's worth thinking about the parts of your disability that are stable and the ones that aren't. It's likely that production won't be insured for any matter currently causing you a problem. Be honest and fill it out as best you can and don't worry this is a confidential document and not seen by all of the cast and crew. Ping it back to them as soon as you can.

You will also be sent a contract, either directly or via an agent if you have one, depending on the level of production this can be short or look like a copy of War and Peace. Contracts differ but most companies use an Equity standard contract with Equity agreed pay rates. For most TV deals you are paid for a set number of broadcasts and then a repeat or residual fee will be paid to you at a percentage rate of your initial fee. Most pay is calculated on weekly engagement i.e. how many weeks you are needed for. Some commercials will most likely offer you a "buy out" which is a larger upfront fee for you to agree to no repeat fee's, which is why a good commercial can pay big money. If you are unsure of what you have been sent then I suggest contacting Equity who might be able to help, even if you are not a member they will look into it as other Equity members may be working on it. As part of the process of telling you that you have the job you will have been presented with an offer. It is up to you or your agent to negotiate that fee and agree on terms of your contract. This negotiation might go down to the day before you begin filming,

and you might not have actually signed the contract before you begin. It's worth knowing that you won't get paid until they get the contract back, so the quicker you sign it and get it back, the quicker they pay you.

Production

You'll by now know your filming schedule and be itching to start. On your first day you will be introduced to so many people that your head will be swimming with names. Normally a studio or unit base where you are filming will be the place you spend time waiting to perform your scenes. If you have been honest with the producer, then you should have access to everywhere you need and be able to relax and get yourself ready for your performance.

Before you begin work look at your call sheet, this is the document you have been given telling you the scenes you are doing that day, on it should also be the contact details for the key crew members for this shoot. Find the medic, each production has one, this person is a good contact to find early on and introduce yourself. If you are prone to infections and carry antibiotics, or need painkillers, they are the ones that have the job of keeping people healthy. You will soon see that everyone calls on the medic at times, even crew, while you get scenes off your crew members don't and even a small cold can really take a toll. The medic is likely to make themselves known to you early on, but try and find them first and say hello.

An actor I know once said "darling, they pay me to wait the acting I do for free". What he meant by that is that filming is mind numbingly boring. You will be waiting for hours and

hours between scenes. If you are on location you will be in the middle of nowhere with bad phone signal, and be hunting for a place to charge your phone or tablet. This is the nature of the beast, as you are only onset for the times you are actually needed in vision. The rest of the time you are told to step off set and relax. There is only a finite amount of tea and coffee you can drink in one day and sometimes you will be crawling the walls trying to think of things to do. Try not to get too distracted as it can be easy if you're waiting a long time to get into watching TV or playing a game and forget that your actually at work. But on the other hand don't sit shaking with nerves in the corner. Most actors find a happy medium between keeping entertained and then taking time out to get ready just before travelling to set. Time a last minute toilet break, once you are on set stopping to use the toilet eats into time. When they give you a half hour warning, as I say to my son before a long car journey, "go for a try".

When you travel to set you'll join a circus of cameramen, lighting engineers, directors, runners. All you need to concentrate on is acknowledging the director and AD's and listening to instruction. You are likely to be approached by a sound engineer to fit a radio microphone depending on the scene. A radio microphone normally has a part that will be hidden behind your collar attached to a long wire and a battery pack that fits in your pocket. Luckily wheelchair users have more than enough places to stash this battery pack out of sight. The sound engineer is likely to be really polite, they will say what they need to do and ask if you would help run the cable as they really don't want to put their hand down your top.

Screen acting is very different to stage acting, positioning is everything, you will have to hit a very specific mark on the

floor without looking at it and deliver your lines. You will normally go through a line run and then block the scene move by move. This is the time to raise any problems you might have if you have been asked to do something physically impossible. Once you know where you're going to be and what you're going to say you normally get a camera rehearsal. Any little tweaks are made and then you are ready to film. You might be asked by the camera department to "take your mark" or "can we see you in your end position", what they are trying to do is establish the focal point on you in that position. It's a technical thing and in simple terms, they want to make you not blurred on that mark. It's really good to always listen to these people, on a busy set it's hard but the quicker they mark it the sooner you film. You might also be asked to "take your eye line', which means look at the person you are going to be speaking too. The camera team are trying to frame you beautifully, make sure you are in focus, and follow your actions throughout the scene. It's technical stuff but I can honestly say that in the UK we have the best crew in the world, they are so fast and so good at what they do. That's why we have so many American films being filmed here, we are world class, and should be proud of it!

As they are preparing the camera and rolling up on sound and film this is where you need to really focus and concentrate, everyone has their own way of doing this. Closing your eyes and taking a deep breath is one. You will hear the words "turn over" and then a little pause before "sound speed" next will be the slate (clapper board) maker if you are using one and then" standby" followed by "Action". If you're closing your eyes these words come quick and fast at times so be sure to have your eyes open on or before "standby". A lovely actor called Johnny Guy Lewis, who played my Dad in Desperados once

said to me that just before your close up shot closing your eyes makes your pupils become larger and makes your eyes look nicer in the frame. It's stuck with me as I also think it's a brilliant technique for focusing performance.

To complete a scene, you will do many different shots, in its basic form you will do a wide (master) shot and a close up for each person in the scene. You may have a two shot, where there are two of you, it might be a point of view. In all honesty, it depends how big the budget for the film is. A film with a massive budget has time to create beautiful shots and cover the smallest detail and make it look like a million-pound film. Some TV shows, just need to get it filmed and will rocket through these as quick as they can.

Speaking of pace, an average film will shoot between 5 – 7 pages of the script a day. At that pace, you can afford to be a little artistic, do a few more takes, and film at a steady pace. Soap Operas can film 35 pages a day! Using multiple filming units and by using more than one camera. They are getting the wide shot at the same time as the close ups. You can film a scene in a soap opera in one take, that's it, it's that quick. If you are going into a continuing drama (Soap Opera) be prepared that the pace is phenomenal. You really have to be on you're A game. Which is why I always laugh at people who say that soaps are bad, when you consider how much they film in a day, on the budget they do, and the level of performance that goes to screen, they are a power house of film making. I would happily employ anyone who has ever worked on a soap as I know they can deliver work at an incredible pace. For example, I produced a UK feature film called iWitness, to complete on schedule and budget I knew we would be needing to edge shooting 8 pages a day with no scenes getting dropped. My first choice of assistant director was a guy called Andy

who worked on BBC Doctors, I knew he was absolutely the best AD to keep my shoot on schedule, we hired him and we completed everything, according to schedule and on budget. In filming time is money so be aware of the project you are filming as you will experience a different pace for each.

Film sets are very compact. You have a large amount of cables and tripods for lights and camera's. Wheelchair access can sometimes be very limited and once you are on set lights and equipment will box you in. It is worth knowing this as if you are leaving shot mid scene you might have to squeeze yourself into some very small spaces and sit very quietly while the scene continues. When you finish for lunch be vocal about camera operators moving cameras to allow you off set as it can be a mad scramble for lunch and you don't want to have to knock over equipment or handle anything expensive yourself because people have disappeared.

Many directors film people in shapes, squares and triangles and circles. You will find that they might have to do a few more set ups to get your shots as sitting down you are at a different height and they will need to cover your dialogue and looks, especially if there are lots of artists in that scene. If you can't see the camera, the camera almost certainly can't see you. If you find you are getting masked all the time and you have important lines, then you need to be telling the 1^{st} AD and Director. Find the balance with your fellow actors though as if it is someone else's epic moment it might be appropriate to slip nicely into the background. Watch out for fellow actors to make sure you are not going to hurt someone in the blocking of the scene.

Exterior shots can be tricky. If you are working with non-disabled artists, you will probably be looking up into the sun for the majority of the scene. There are no words of wisdom on this apart from try your hardest not to spend the whole scene squinting. As you are not in the controlled environment of the studio or set you will also have to negotiate different terrain. Be honest with the director over difficulties you have. You will also have the weather to contend with. It can be very cold sitting outside for hours so don't be a hero and when a costume assistant offers you an overcoat make sure you take it. Costume assistants sometimes also have hand-warming products that look like a big tea bag. They are full of crystals that keep warm when you shake them and can be hidden in layers of clothing. A scene with your teeth chattering will not be a good one so smile nicely at them and they will be happy to keep you warm. Get costume to buy some thermals, I know these don't look too sexy but believe me they are a life saver. If you are cold say something, if not you might be making yourself more ill in the long run which will be bad for the rest of the shoot.

If you suffer from a bad memory and are concerned about remembering your lines most productions give you a daily list of scenes, which will have your lines on. These are called "sides" and are on A5 and are small enough to fit into your pocket. Better yet, hide them somewhere on your wheelchair. It is impressive how much script you can hide on a wheelchair and when the word gets out with your fellow cast members you will suddenly be who they all turn too to have a little look at script.

Most of all enjoy the experience of filming. You have come so far and should really enjoy the thrill of bringing a character to life scene by scene. Remember that this project is still an

audition, as it will someday appear on your show reel when you are looking for other work. The energy on set can sometimes be amazing, the crew do act like an audience and I have made grown men weep doing a scene, it's an incredible feeling and crew members will tell you if they enjoyed what you did. This is nice as it will be months before you see the finished film and I always like being reassured from crew that they enjoyed the performance.

Film sets are one of my favourite places on earth, the idea of all those people working together to create something and the clash of technical ability and performance. Words really fail to describe it, so once you are there enjoy every minute of it.

Post Production

After you WRAP and are finished filming you are not completely done. Although you will be seeking other work and hopefully getting ready to film something else you may be called in to ADR (Voice over) some scenes. This is done on occasion because there was a technical problem with the audio when you were filming. It will normally involve going to a studio for a morning and re-recording a few lines or odd words of dialogue. The studio is likely to be in Soho, the nearest tube presently is Green Park, then you walk through Piccadilly to Leicester Square and you are almost there. ADR suites can be in buildings which are not accessible, check with your producer that you can get in the building. Once you are in the building the recording studios normally have very heavy doors, take a mate with you if you think you might need a hand. You will have to say it in exactly the same way as you did when you filmed and get the lip sync right. It's tricky at first but you will

get the hang of it. It can be very quick to do and you get a sneak peek at the finished film.

Once the film is edited you will either have a Premiere to attend or a launch night if it is TV, you will have to attend events and publicise the project. Talk to journalists and do interviews and radio shows. Enjoy this part, as this is where you get to be yourself and build your own fan base as well. Never be negative and if something bad happened on production or if you didn't enjoy it don't talk about it. The producers won't be particularly pleased and it won't make them want to work with you again. Remember your career is a marathon not a sprint and being negative can have major consequences. Be prepared to travel and publicise your film as this in turn can lead to more work. This might mean that you have to research event locations online to check accessibility, it is worth doing this and attending events you are invited too.

Now you have experience return to "The Basics" section, update everything you can and start the whole process again. This is the life of a jobbing actor and there are thousands of people doing this every day. Now you have an understanding of the whole process and you should have a clear idea of where you fit in that process.

You will also build up a network of people you have worked with and if you are lucky find new friends. They say every now and again you work on a project where you meet a lifelong friend. As your career develops and grows so will theirs. These are the people to hold dear and will follow you on your journey. This is possibly the nicest part of working in the acting industry.

During all of this it is important to know your body, know your limits and keep yourself as fit and healthy as you can. A good diet, exercise and making sure you have all your prescriptions and everything is ticking over will serve you well. You are your product, so take care of you. Mind, body, and soul, be ready for the time when you get that opportunity to show the world what you can do.

In keeping with the idea of mind body and soul unfortunately we have to talk about something that is going to test all of that. It is impossible to write a book about how to be a disabled actor without discussing what to do when you are not being an actor. At the moment as discussed in earlier sections there is a deficit in the amount of opportunities for disabled actors. Hopefully this is going to be resolved as quickly as possible but start thinking of a contingency plan. What are you going to do for money when you are not acting? What job can you do that will allow you time off to audition? Normally for non-disabled actors they find many jobs in hospitality and work nights and weekends to keep days free for acting, for disabled artists the answer isn't so clear. It's unlikely you will go from job to job and at some point you will need to bring more income in. Unfortunately, I can't answer the question of what to do. It entirely depends on your circumstance and where you live and your earning needs. However, I know that the skills you have as an artist are of value, a value that is not limited to the media industry. Whatever you find to do please don't let any rejection from acting effect your confidence as a person, the two are not interdependent. The reason you are rejected for a part is that it wasn't right for you, not that you were not good enough. Equally when you do get a part, it's because you were perfect

for it, the right person for the right role. A casting director saying no is not a reflection on your talent or you as a person.

It is human nature to become a little disheartened to constant rejection, and it is so hard to remain confident and to not become negative. If you try hard enough you will succeed, but every actor has to pay their dues and spend a good few years getting known in the industry. Unless you are exceptionally lucky this is a long journey with highs and lows, but with hard work, talent and determination you will succeed. Focus on what you can do to increase your value, do what you need to do to survive financially, use your skills in every way you can and enjoy this journey. When you get to where you want to be you can look back and say "yes, I made that happen."

A methodology is born.

To really establish disability as an art, worthy of study and understanding let's look at building a methodology on my work and findings in both theatre and TV/Film. If we apply this as a process to all disability representation I hope that we can lay a foundation structure to work from.

I'd like to introduce a system of the three "**P's**".

Be **Prepared**, Be **Professional**, Be **Patient**.

This is specific to the disability part of the character and does not replace standard preparation techniques for acting, this is an addition to existing methodology.

Be Prepared

To be prepared you must:

1. Analyse your own disability in detail. Your physicality and your cognitive state.

2. Establish if the disability you are to play is an acquired disability or one the character has been born with.

3. Research the disability in full:
3.1 Analyse physical traits of the condition
3.2 Analyse the effect on cognitive behaviour
3.3 Engage appropriate NGO/Charities for research.

4. Compare at length the differences between your condition and that of the character, for example a paraplegic will sit differently according to the level of the Spinal Break. Consider:

4.1 Characters physicality
4.2 Character Cognitive state.

5. Consider mobility aids – is your wheelchair compatible with this representation, if it is a period drama was your wheelchair even invented? You must speak to production ASAP if you will need a different mobility aid as it will not be immediately obvious to an art department. Flag up as required.

6. Consider the production and any access needs and make them known. Make people aware of any current problem you are experiencing that could impact the shoot. Ensure you

consider the entire length of the engagement and make issues known as early as possible.

7. Rehearse the physicality of that character, either in your home or by visiting a shop and only using the physical ability that they can use. Don't however put yourself in danger or cause yourself harm. Apply discretion.

8. If possible, and with the support of production and NGO's/Charities, engage people with that disability to be able to speak to them and learn the intricate nature of the disability.

9. When you have the entire script, or in a continuing drama the minute you receive it. Highlight any potential script problems either with staging or representation that does not fit the character or the disability. DO NOT leave these until the day you film, report them instantly.

10. Learn your lines and be off book, even if cast members appear to wing it, be better, know your lines.

11. Concentrate on your health and report all problems as soon as they arise. Keep medication up to date and maintain regular contact with the production medic.

12. Be prepared to sacrifice a large amount of your private time. For those who have never experienced it, filming can cause extreme fatigue. Filming must be your priority, don't plan large amounts of engagements until you have fully settled into the process and can cope with the heavy schedule.

Be Professional

1. Be on time – it's simple but the biggest sign of professionalism.

2. Be prepared to put people at ease and communicate needs.

3. Understand that you are a small part of a massive team that all have different jobs to do. Know your role in the whole process.

4. Understand that in order to facilitate your performance, many people have worked hard to get to this point. Be careful not to disrespect any attempt to facilitate you.

5. If a problem does arise be clear about the needs you have and think of it as a lesson to learn for the person concerned. Don't be argumentative and aggressive as tempers on film sets can rise quickly due to the pressures of filming. Consider how you communicate what you need.

6. If you have any sensitive issues or a problem with any member of staff make it known immediately to the Producer. As Producer they are responsible for your safety and well-being. They will decide how to proceed and filter the information as needed.

7. Be aware that as a disabled actor in an industry with very little opportunity you have the ability to make disability representation a pleasant experience, one that a production may wish to repeat again on the next project.

8. In line with point number seven, it is in your interest to be professional, filming is a fluid industry and directors can quickly progress from one small job to a much bigger high profile project. It is not just limited to directors; everyone you have ever worked with may someday be the decision maker in the job you want in the future. It's argued that this industry is 40% what you do on screen and 60% how you are off it.

Be Patient

1. Set long term goals and short term actions to build towards those goals

2. While waiting for opportunity research the industry and build a database of industry professionals.

3. Keep your head shot, show reel, and online profiles up to date.

4. Maintain social media and seek out opportunity online.

5. Network with industry figures.

6. Establish a secondary income, or several, to supplement income between jobs.

7. Remain positive, proactive and passionate.

A dear friend of mine called Larry who lives in LA and has a job in the industry we would all kill for once said to me that the reason I was so patient is that I had spent my life waiting for an elevator, while the rest of the world was running up the

stairs. That stayed with me, as it was a beautiful observation that as disabled people we are by nature patient, we have no choice, we are prepared and research even the smallest event such as a trip to a new restaurant, and access needs. I'd argue that we are professional, the barriers that stop us from working are many, once we get work we feel a need to prove ourselves. Using Larry's poetic analogy, the elevator will come, and in the end we will get to the same place as everyone who is running up the stairs.

Proud's hierarchy of disability.

Those of you aware of the work of Abraham Maslow will have chuckled at the title of this section. For those unaware of his work please research Maslow's Hierarchy of Needs, it's a fascinating theory on human needs and has many applications when considering characters and characterisation. For me when dealing with disability there is a relative hierarchy of disability that needs to be considered for effect on a character. Let's take a look.

```
        ┌─────────────────────────┐
         \  Terminal/ Life        /
          \  Threatening         /
           \───────────────────/
            \ Chronic/Incurable /
             \───────────────/
              \ Temporary/  /
               \ Curable   /
                \─────────/
                 \ Minor /
                  \ailment/
                   \───/
                    \ /
                     V
```

Fig 1.1 – Hierarchy of Disability.

In this hierarchy, we are considering the impact to our character. A character with a terminal or life threatening disability or condition is going to have much more focus on the disability than a character with a temporary, curable condition. As we ascend from the least threatening upwards the pyramid grows in size, as does the importance in relation to the character. It is possible to play against this, for example having a terminally ill character that chooses not to focus on their condition, but even on a subconscious level it will have a massive impact on their actions. In a mirror image, you may have someone with only a minor ailment that is obsessed by it and focuses on it, in that situation as an audience we would be aware that the level of concern is not in proportion to the condition. This is most commonly referred to as a hypochondriac. As you begin to examine the importance of disability in relation to characterisation it opens up a broad

range of possibilities. It is possible for example for a character to pass through all of these stages, and the character arc will alter dramatically at each stage. You will see I have purposely not included a section for non-disabled, as I do believe that for the most part everybody as some ailment or body function that they are aware of and would wish to change.

Proud's Circle of Disability

In terms of building a character there are many methodologies out there and I recommend an approach of continual study of all of them, every actor finds a method that seems to suit them and makes them prepared for the performance. In the world of disability as we have discussed there is an added element. So, let's explore that element in what I would call, circles of disability.

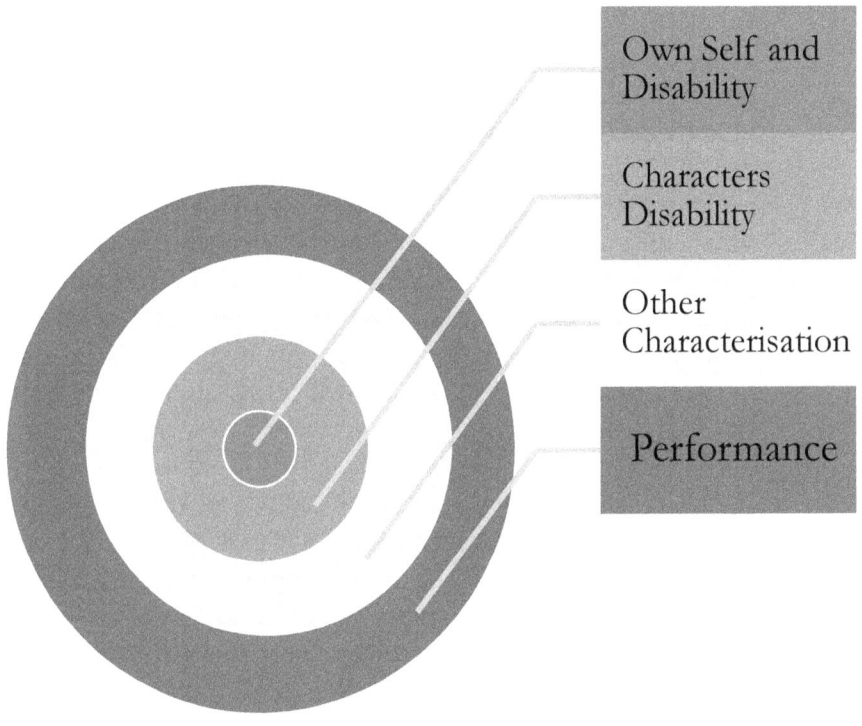

Fig 1.2 – Circles of Disability

If we consider acting as the layering of many masks upon us in order to present a character, disability is a separate mask. At the very core in red we have ourselves, our persona, and all that makes up or own character and disability. Included in this must be a good understanding of our own disability and limitations. Outside this circle we must wrap our character's disability, both physical and behavioural attributes. Outside this is any

other characterisation for the character in line with the normal standard approach to acting. At the outer layer is the performance that we give. By seeing it as layers radiating from the core of us we are able to be aware of each element and prepare each in its own right.

This model only works on the basis that you always bring your entire self and disability to the character, you are 100% you. In addition to that you add parts of the character's disability and character. As disabled actors we cannot lose our disability, it is always there, so it must be part of the matrix of the performance you give, even if it is disguised by the addition of other factors.

As an actor who has been asked to play beyond my disability, to play characters that have less physical movement than myself, it is physically very tiring. It demands a high level of control over my body and a concentration level to maintain that throughout the performance. This can only be done with a good knowledge of my own physical limitations. There are inevitably some disabilities I would not be able to portray as I could not physically achieve it. It is only possible to go beyond your disability to portray a more severe disability if you are able to incorporate the disability you actually have and mask it fully. We must be honest and not try to perform a character that has more ability than we can reasonably manage. It may be possible to use stunt doubles or camera angles to mask a disability but this is harder to do and requires thought.

This is the start of a methodology of disabled acting. Each artist will find their own way to achieve a performance, a way of preparing for performance and at the critical time switching

off and being in the moment. Acting is a muscle, and the hard part about being a disabled actor is having months in between performance, lying dormant and then being expected to be on top of our game. It's a hard, brutal industry but all the parts we have discussed can change your mind set. Make you focus as a business and a professional artist.

"Art is the only thing that separates us from monkeys, for the disabled it feels that somewhere, some great ape is keeping us separate from the world of art..."

New Filmmakers

This section is for new disabled directors, producers and writers. It is pleasing to see a focus on disabled talent behind the camera from our industry, when the industry has people in position of power behind the camera will we see real change to disability representation.

As a new film maker one of the hardest problems to overcome is "how do I get my film financed, where do I start?" All film makers go through this, access to finance is the hardest thing about making films. Expect to be told no 99% of the time, and that's if you can get anyone to read your project. To your advantage you are unique, as a disabled film maker nobody has your life experience and that is what the industry wants, people can go to university to study film but you can't go and study being disabled. You have a golden ticket to a world full of drama and comedy and interesting characters.

Start small, aim to make a short film of under 5 minutes in length. Get a camera, film it in your living room and edit it using free editing software, if you want to be a film maker, **make a film**. It will probably be bad and you will hate it but you have started to learn what you would do next time, also if you do happen to make a great little short, get it on YouTube and get it out there, or enter it into a film festival if it really is good. It will be a calling card showing what you are all about.

A lot of film agencies run formal short film funds where you have the chance to win finance for a bigger short film. These are great but competition is hard, winning is just the beginning of a lot of hard work. If you win one there are a lot of forms

and paperwork you will have to fill out. You really do have to go into it with a strong team and a clear idea of how you are going to deliver the project. Deliver what you said you would, when you said you would, and you might be trusted with more finance next time.

Once you are starting to tackle bigger projects start venturing into the world of crowd-funding. This can be great for amounts up to £10,000 but please don't be fooled into thinking you can raise more, unless you have the social network of Justin Bieber you won't have the reach to find over £10,000 worth of investment.

Please don't think crowd-funding is begging, it isn't. It is simply finding your audience before you make the film and asking them to be involved in the production. Really identify the target audience and connect with them. There are many articles online giving advice on crowd-funding and they are pretty spot on. Don't be afraid to try this but keep your expectations realistic. A guy from Chicago isn't going to wake up tomorrow and give you, a complete stranger, $100 towards your film. Your audience may invest in the project if it is something they wish to see, some may also like the idea of being part of the film making process.

When you are moving on to production, please don't think that physical disability will impede the art of filming. We are seeing an absolute revolution in equipment, I myself have a quad-copter and camera that allows me to produce tracking shots and steady cam type shots with a movement of my thumb (please be aware that this is just an example of new technology and a civil aviation licence is now needed for these drones if using for commercial work). Filming high quality footage is

now easier than ever and the cameras are getting smaller, a Cannon 5D can film great quality and is relatively easy to hold. Find a good cameraman or DOP and ask them for advice. Make sure you have included any costs of equipment you need in your budget, for example a small monitor could be good for you as a director with less mobility as it means you don't have to be anywhere near the camera.

There are lots of guides into independent film making and they are all worth reading. Production companies might be actively looking for diverse crew and are going to really want to work with you, especially if they are applying for funds from anywhere with a set diversity policy. Really research the companies out there and who is making films you like. It isn't that hard to find these people and start to engage them on social media. By working on bigger scale projects for companies you can gain great insight and contacts for getting your projects off the ground. There is always someone out there with a bigger project than yours and you can learn lots by shadowing them.

When you have finished your short, or if you are very lucky, your feature film you then have to get it to your audience. The normal route for this in the UK is to enter your film into a film festival in order to try and secure distribution at a film festival market. There are thousands of festivals around the world and each will have its own qualifying condition. For some festivals you will have to pay to have your film considered, even if it does not get selected, for short films the cost is slightly less. Once you have your film played at a few notable festivals you can officially get it listed on IMDB, which makes it more of a notable project. At film festivals films are acquired by sales agents and distributers who will then look at releasing your film cinematically in various world territories. If your film is

released at the cinema you will qualify for all the video on demand services (minimum theatrical release applies) and hopefully acquire enough interest for a TV release. This is a very watered down summary of the life of a film but it's good to get an idea off the stages of a film release. Obviously the bigger the film and the more hype and buzz about it, the easier this process is. For most it is very hard to get it into a good festival, if you do it is hard to get it seen by sales agents and distributors, if you fail to get a cinematic release then you don't get your video on demand release or TV deal. The competition is high, there are only a few art house cinemas that have the capacity to show independent films, most are contractually obliged to show a certain percentage of studio films as they rent the latest projectors from major studios. This makes competition for the remaining screenings very hard. One suggestion is to approach the owner of the cinema and discuss the idea of making the screening an event! Get cast to attend etc. anything that will ensure that the owner has a packed cinema for your screening.

If you have made an amazing film, with a tiny budget but massive production value, it wins a few awards at a few festivals and gets some great reviews. you may well get the short cinematic run you need to really get your film out there. If this happens you are more likely to be able to pay back your investors and doors will open to allow you to step up to the next level and aim that bit higher in your next project.

Listed above is what would be known as the normal business model and value chain of an independent film release. However, as a film maker now is a very exciting time as the old market model is dead, DVD is dying and video on demand is the new king. You can crowd-fund your film, make it and self-distribute it via many different online platforms. You can

show your film in 'pop up cinema'. There are so many new and emerging ways of getting your film seen. The important thing is to make it, and make it good. Really know your audience and be prepared to think slightly outside the box in how you get your film to them.

The digital revolution is enabling more parts of filming to be accessible to disabled film makers, so research, find your best options, but more importantly just make stuff. With each project you will grow, you will learn and you will establish your voice as an artist.

"An artist is only limited by imagination; a disabled artist is only limited by opportunity."

Experienced Actors

From having one paid job to having 20 years of experience, this section is for you. It is safe to say that most experienced disabled actors have been asked about disability representation at some point in their career, and by now most will have formed an opinion of this book against the knowledge they have. Do you agree? Would you add anything? Has this inspired you to write your own experience? Let's hope so.

Before we look at any perspective I have formulated over a decade of experience, let's look at a small cross section of talented disabled artists and see if we can find any common ground.

As discussed many times within this book there is a wealth of experience in the field of disability representation. When considering who would be best to approach for this section these three people sprang to mind. Between them they have over fifty years' experience in TV and Film and they are artists that I have remained friends with throughout the years. First up is actress, writer, disability consultant, and lawyer Shannon Murray. Shannon is an exceptionally talented person and most of our chats have surrounded the issues in this book. Her work has covered, acting, modeling, and journalism and it's been a pleasure to see her go from strength to strength over the years. Next up is one of my favorite people on earth, actor Ben Owen Jones, I worked with Ben on Best of Men and spent most of my time laughing with him. He is such a pleasure and gent to work with and has a lovely positive attitude and a smile that charms people. Sometimes getting hold of him is like trying to track down an Amazonian tribe, as he is a country lad, but he is

worth finding. And last but in no means least is Julie Fernandez. Julie and her husband are close personal friends of mine and have been for years, they have fed me on many occasions and we have shared many bottles of wine discussing the industry and disability rights. Julie has been an actress and disability rights campaigner for over 20 years and is a fountain of knowledge. Let's see what their thoughts were on disability representation.

In order to allow a slightly scientific approach all three were asked the same questions in order to see if there were any similarities in the responses.

The first question was what is the biggest challenge you face as a disabled artist?

Shannon: *The biggest challenge is definitely the lack of roles for which I can audition, until blind casting is commonplace I can only go up for roles where the writer has indicated that the character is a wheelchair user. This limits considerably the number of auditions I can attend. The second challenge is that even when roles are written, the characters aren't always incredibly challenging, they can be a little stereotypical or rather bland, that's frustrating as an actor because you always want to perform interesting characters that push your abilities, and allow you to explore the emotions of that character and scene. I feel like writers need work with more established disabled actors to understand the way in which various disabilities can work within a story without the disability BEING the story. We know our disability, we know our bodies, we know our acting skills, let us work with you to create incredible stories and about life and relationships not just wheelchairs and hearing aids.*

Ben: *Attempting to become a professional actor is troublesome. Finding the right training, then signing with a decent agent are hurdles for any would-be performer, before even attempting to get enough paid work coming in to actually make a living. These hurdles exist for all would-be professional artists, not least for an actor with a disability*

Julie: *I think the biggest challenge we face boils down to able bodied peoples attitude towards disability, it has been like that for decades. Historically within a family unit everyone counted to bring money in and to work the land to bring in food to feed the family. Disabled people are seen as a drain on that resource and often because of their disability can't support the family in the same way. I think it stems back from that really. I know it sounds odd but bring that forward in time and it was not even 100 years ago disabled people were locked away in institutions. Unfortunately, society see's disability physical or mental as a difficulty, as a drain on resources and the system and I think that they see this for many different reasons. When abled bodied people look at us they look at the thing that they fear the most, to become disabled. The reality is that disability comes to everybody at some point due to age. It is every abled bodied person's worst nightmare, the thought of becoming disabled. For many it is subconscious. The fear of becoming paralysed, going blind, losing your hearing, or having a heart attack is not something you want to contemplate. Everything that we are is everything they don't want to become.*

Society often thinks that we are not clever enough to be employable, that we don't have emotions, we don't have sex or have children, What disabled people have sex!!! You couldn't

possibly. So the whole of society's attitude towards disability is that we are seen as lesser, not equal even though we are all human. Being from another ethnic minority doesn't stop you from getting up the steps to that job interview but being disabled can often mean you can't even get to the door. So we have two major barriers the first is people's attitudes towards us and the second is the physical barriers that we face like steps and all of those things that prevent us from getting through the door. Out of the two, I think societies attitudes is the biggest one to overcome.

It's very interesting that all three have given a slightly different approach to this question, Shannon is focusing on roles in terms of quantity and quality and actually links to Diedericks earlier point about not always having the disability as the story. Ben points out the very valid point that acting is a hard industry for all, and that this is no less for disabled artists, the same hurdles exist. Julie goes deeper and looks at the psychological response of society to disability. All three responses having merit and showing how wide the debate on this subject has always been.

What would you like to see happen to increase the number of roles for disabled artists?

Shannon: *Casting directors, writers and producers need to agree that disabled actors can be seen and will be considered for non-disabled roles. I realise it's not a popular choice but perhaps it's time to start considering putting quotas and financial incentives into place; the film and television industries are a business, companies want to make money so you have to target their bottom line to get their interest.*

Arguing that they're not representing our diverse society holds little appeal to a producer looking for a prime time ratings winner box office smash.

Ben: *In my experience there seems to be a reluctance to cast against type. By now we (as a society) should be beyond the stage of praising those characters on screen or stage, with a disability not referred to in the plot. This should just be normal.*
And at the same time I don't agree with this issue whereby some people are up in arms at the fact a 'non-disabled' actor plays a character with a disability. There are far too many holes in this argument and it saps, distracts attention from the real issue, which is just writing more disabled characters in scripts and casting disabled actors for non-disabled-specific roles.

Julie: *I think that's really simple, before a disabled actor is seen on screen there is often years of work by other people in the production process. Pre-production is where it all starts. We need disabled writers who will naturally think about disabled people within the script, we need disabled casting agents who will automatically think nothing of auditioning disabled artists, we need disabled producers and so on!!! Once disabled people are involved with the entire production process from the very beginning through to the very end then we will see a massive change and an increase of disability representation on our screens. When that happens then peoples attitude will start to improve as it has for other minority groups. The money makers who are ultimately in charge will realise that to have disabled people naturally and organically within the programme/series/film will only increase the financially value as there are a lot of disabled*

people in the world and that means viewers and people who can and do spend money just like everyone else.

Ben has hit on a subject that we will cover in more detail later in this section, it's no surprise that he raises the issue as it is hotly debated and the subject of many of our chats together. It is also interesting to hear him talk about the idea of seeing disability on screen as "normal", are we there yet? Shannon's notion to provide a financial or quota led incentive we have seen reflected in some of the changes being made to disability policy, for example the BFI three ticks goes a long way to leading the way on this. It's a shame that we have to mandate diversity but I do agree at the moment it appears to be the best way. Julie is also raising a brilliant point that once disabled people are integral to the creative process in all roles, diversity will be a natural outcome. It really is that simple.

What advice would you give to new disabled artists to help start and sustain a long and successful career?

Shannon: *Study your craft, even if you can't attend a full-time drama college find classes with talented tutors and keep going even after you start to land professional work. There are long gaps between jobs for disabled actors, don't let your acting muscles atrophy between gigs. Also, make sure you have a job that pays your bills, keep in mind that acting pulls in experience from all aspects of your life, including a second job.*

Ben: *My advice would be to just start acting in any way shape or form that is possible. Look for opportunities everywhere and try to expand your skill-set wherever possible. And like most actors do, find some sort of flexible job or*

livelihood that you can keep going when you need to attend auditions, workshops, training and take time out for jobs but fall back on when times get rough thus hence keeping the old wolf from the door :)

Julie: *Make sure you have a secondary career and income as unless you are extremely lucky and there is no reason why you shouldn't be, it will be tough. You will be spending a lot of time travelling to and from auditions and that costs, so does honing your skills and going on workshops and things like voice coaching. You need to have up to date CV's and photos. You also need to be extremely pro-active and get yourself out there not just in front of people at auditions and events but write to as many people as you can about yourself and your ideas.*

Take the time to improve your skills as much as possible. It's also really important to have a thick skin, you will hear no more than yes, and have no idea why. You will go on auditions that you thought you did badly at but you got the job and you will have auditions that you think you nailed but you didn't get the job. Many disabled artists also write so take a look at other production roles and get involved in that, it could be your way in and also a source of income.

Did you get that? GET A SECOND JOB! This was said by all three, so if you have learnt anything it seems to be don't rely on acting alone to pay the rent, as it won't. In this question all three responses were almost a mirror image, strange that three separate disabled artists all had wonderful insightful advice for new disabled actors. If only maybe someone at a broadcaster could connect these three and others like them with new disabled actors on a more permanent structured scale creating a long lasting self-empowering industry led by talent

for talent... what do they call something like that? Oh yes, a good idea! In this somewhere is the golden egg of the diversity problem, it simply requires the use of the talent we have in a way that creates sustainability.

If you could give one bit of advice or message to the industry what would it be?

Shannon: *Please be more open minded and imaginative, for a creative industry there is a huge amount of narrow minded thinking. Stop ignoring a huge section of society, in recent years big steps have been made for actors from other diverse backgrounds, can we please move forward with disability, and I mean genuine moves to work with the actors and writers, not just more 'talent schemes' and patronising initiatives where we all sit around tables discussing the issues; we don't need that, we simply need the chance to be seen for the roles.*

Ben: *Although I have taken part in and seen a few very successful efforts over the years that I have been involved in acting, it still seems as though there are too many discussions, new databases and unfulfilled schemes out there, without that much real change. Perhaps the only way now to address this is by enforcing much stricter positive discrimination rules and not just for the publicly funded companies.*

Julie: *Employ disabled people NOW in all parts of production and realise that it will only do you good as you will be able to tap into a massive undervalued wealth of viewers that could mean a second or even third series being commissioned. If disabled people are in it then they will watch it.*

For those of you that have seen Monty Python *Life of Brian*, I think what my colleagues are saying is can we stop sitting around agreeing that we have a right to act, and just be allowed to actually act. Direct action and now, no more discussion, talk, debate without actual response and results. As disabled actors we will know if this has happened. Shannon, Ben and Julie's phone will start to ring, and it won't stop. Audition will follow audition and suddenly disabled artists will become a valuable commodity, casting directors will be angry that they wanted Ben, but he isn't available as he is shooting a series and after that is booked for a single drama. The challenge the industry faces is making our mobiles ring, increasing demand tenfold, so that agents are forced to recruit disabled artists like never before. This is entirely do able, but it hasn't happened yet.

Finally, if you could have any role in the world what would it be?

Shannon: *Wonder Woman. I was obsessed as a kid, and I have the height for it - haha!*

Ben: *I'd really like somehow to get my hands on an accessible van/truck/wagon just like the one in* The Imaginarium of Dr Parnassas *by Terry Gilliam and travel round the world with a crazy theatre group making and performing spontaneous art. I would be in the role of Dr Parnassus.*

Julie: *I would love to be in a series like Big Bang Theory that touches people's lives with comedy and laughter and for people to feel so in touch and in tune with the characters.*

We have seen a glimpse at the world of three disabled artists with decades of experience. Like an iceberg this is just the tip, and we would be wise to continue this work to benefit the whole industry.

What I would like to do now, after hearing from Shannon, Ben, and Julie is chat to you about my experience as a producer and how that has really changed my outlook as an actor.

My move into producing was simply in order to get some of my own scripts made. As a disabled actor, I had been asked about representation a lot, and I felt bad as I hadn't actually written anything and put it out there but I was being asked to criticise other people. In the beginning I was very naïve and of course when asked about non-disabled people playing disabled characters I screamed "hell no". Years on and I have a slightly more complex but informed view of the situation.

Let's look at exactly what it is like trying to pitch for film finance over £100,000 in the UK. You have a project you believe in with so much passion, you have spent at least two years developing it and writing the script. You have managed to get it to some key people who agree to attach themselves to the project. At some point you have to approach investors and this is where the situation gets complicated. Many people have defended the use of non-disabled artists in films due to financing and I can tell you with 100% certainty they are telling the truth. They aren't trying to cover anything up. When you pitch to the BFI, Film 4 or BBC Films for development funds or production finance they care about diversity and they want to see it, I have been in that room, I can tell you they ask and they are not impressed if you are not making some serious effort to be diverse. However, the investment they make only

makes up a percentage of the total film financed. They may invest 20% of the films finance but a film is financed by a collaboration of investors so this is where it gets complicated. High net worth individuals and finance companies want to make their money back, it's that simple. If they are convinced they will make the investment back and some profit you have a green lit film. Producers are selling not only the project, but the tax benefits of investment. To a large extent the investor may never even read the script or watch the finished film. They are simply making an investment. How diverse is your bank? Can you even answer that question? My point is you don't think of diversity when you place money into your savings account, it's just a transaction. For investors it is the same thing, they are making a financial transaction and what they care about is the investment, return and risk. They care about the risk of the investment and the chances of them getting the return they were projected.

In order to achieve that they want to know, who is directing, who is writing, who's in it, the track record of everyone involved and how successful they have all been before. If for any reason any key member of the film pulls out before filming the investment could be lost and the whole thing crumbles like a house of cards. Stick with me here because we are getting to the point. A film such as The Theory of Everything would have been financed with Eddie Redmayne already in line, if not attached to it. If he had pulled out due to other commitments and an actor of his equal could not be found, the film would not have been made. My point is that we would have never been seen for this film, it was never our part, it belonged then and always to Eddie, who can I say delivered a spellbinding performance.

The same is actually relevant for how West End shows are financed as the investors want to know they will make their return. An A list star in a film or on stage is going to have that box office draw. Think about it for a moment. If you had £1,000,000 to spend investing in a film, would you not want to maximise your investment? I fully believe this is not always going to be the case, and I thank Eddie for actually doing the film justice. If you are going to represent disability then do it well, and he did! I have said this before and I say it again, we are just not there yet.

It baffles me that disabled people would waste time protesting outside of a Film Premiere when they are protesting in the wrong place, why aren't they protesting at the film festival market where that film closed finance? Or outside the studio that greenlit it? You at least would stand a chance that the film financier will see your placard and be able to back out of the investment.

To really play devil's advocate, in order to create a balanced view, I went up for a job where the character had cerebral palsy, I got to the recall stage and found myself up against an non-disabled actor. Tell me what is the difference between me faking being CP and him? Neither of us can lay claim to having any links to cerebral palsy?

Okay so in a way to rescue your opinion of me as that last sentence might have made you a little hot under the collar, I am with you all the way. I am just suggesting in a very Don Drapper - Mad Men way that if we don't like what is being said, we should change the conversation.

There is no point with us getting upset about that very small percentage of representation of disability that are performed by non-disabled actors in film and in the West End. However, television is financed differently and to a large extent a production company will pitch to a channel for funds to make that show, the money is coming from one source. In TV there is a bigger argument that you should never have a non-disabled person playing a disabled character. Although we are now all obsessed with finding that long running box set that has worldwide sales appeal, I think all will agree that TV offers us a fertile playing field in order to develop careers and talent. There are always exceptions to any rule and in some cases where a production company and channel have made no attempt to employ authentic disabled actors I do start to question why. This is where the pressure needs to be applied.

The reason why this non-disabled actor debate really makes us rage is that we are frustrated at the lack of opportunity for authentic disabled actors. It is a larger argument about how the industry has failed to represent society equally. If we were all working as regular cast members on things would we really care if an A list celebrity sat in a chair to win an Oscar? If there was enough work to go around? I'm not convinced we would care as much. So, what do we do? How do we change the conversation? The question isn't why aren't we lead in a movie, it's why aren't we all in a soap? Why we didn't get seen for that drama? Who's casting that English independent movie? And controversially, how can I make myself more employable? Surely those questions would be a better use of our time and energy? There are some things that for the moment are out of our reach, so let's concentrate on what we can get. Let's build from the ground up. I promise you if we shift our focus to the smaller wins, with the ideology to build careers and open up

more opportunities at a realistic level we will someday have our face on a film poster on the side of a bus in London.

The problem we have is a legacy of broken promises, and believe me I have witnessed how frustrating that can be but there is a massive willingness to overcome this gap in representation by the highest level of the UK industry. We must understand that there is a fear for the industry of getting it wrong and we need to do more to help. Thinking of it in terms of them and us just isn't helpful. Our industry is built on collaboration, and this cannot be solved without everyone sharing knowledge and working together. Every one of us has a responsibility work hard and make sure this is an issue that dies with our generation.

The trick is we can't give up, we can't give in. We have to make sure that the next generation does not have this fight. That for someone born today, who happens to be disabled, can grow up to be a superstar. In a nod to my reworked "I have a Dream speech" *Appendix A*, no fight for equality is easy. It's going to take years and years, but every once in a while, we see a landmark moment, a defining point that hints to the future. The Paralympics was such a moment; it was a disability event and it sold out a 50,000-capacity stadium for two weeks! The audience wants us, we feel like we belong, we won't give up and we won't give in, sooner or later something is going to give. Like a dam about to explode under the intense tide of water the industry is showing signs of cracking. We must push. There are people in positions of power that are committed to change and actually making it happen. We have to be a guide for them, show them.

I have to insist on an Ian Drury approach of total anarchistic chaos, mixed with encouraging the act of teaching. So my brothers and sisters in arms, I want you to go and inspire the next generation, pass on knowledge, email anyone and everyone that might employ you, show people your show-reel, ask for general meetings. Offer to teach people, offer to consult, offer up your talent and your time. Show the world the wisdom you have. You might be thinking "steady on Dave, have you been at the loopy juice", but look at your phone right now, in that phone is an email or number of someone you have worked with, someone who admired your work and meant it when they said keep in touch, so go keep in touch! Create scripts, attend courses, network, create crowd funding projects, do all of it, but most importantly **make yourself heard**!

Summary

Art is about expression which links directly to the human rights act. The art of disability - or rather the expression of disability is important. Thinking about it this way is a fresh viewpoint. What is it we want to express about disability? Who wants to express it? How do we weave this expression into cultural life? As we looked at in the opening of this book we need 44,000 disabled artists to be given the opportunity to express themselves.

As a genre, it is about understanding that disability can be a category of its own. Genre is used every day by consumers choosing a type of film to watch. Making disability a genre raises the subject matter to join the likes of comedy, horror, drama etc. These genres can be mixed, we can have a comedy drama for example, so giving it a genre of its own does not inhibit its presence in another genre. It's interesting to look at the genre selection on Netflix, other minorities are represented as a genre, enabling viewers to choose content specific to that minority, disability has not yet been invited to the Netflix party. It isn't just Netflix, the point being made is while it is socially acceptable and encouraged to be able to search for other minority genres disability has fallen through that gap.

The problem we have is that currently that Netflix preview window for disability as a genre would be rather empty. Or would it? Actually, if you include all films that feature any disability Kings Speech, Rain Man, Born of the Fourth of July, to name a few, it might surprise people to realise just how many portrayals there has been. Arguably not authentic, or from diverse voices but disability is no stranger to our screens.

Never the less they are portrayals and all films that have been commercially and critically successful. It seems that the very thing that frustrates disabled artists might actually be the biggest trump card... Disability sells! Disability - critically unrepresented in an authentic way and not in high enough proportions, can make money and win awards. This is show business not show bankruptcy, our greatest goal is to actually marry the success of unauthentic portrayals with authenticity and expression of true disability.

It is entirely achievable to have a high quality and quantity of disabled artists onscreen in modern day society. It is through media that social understanding and society changes. Disability feels like the last taboo of film and media and by reading this book you may have developed a deeper understanding of the importance and the need for inclusion of disabled artists. You have also learnt to see the subject from a slightly different view point. If you are a new or existing disabled artist hopefully you feel inspired and empowered to continue and to set your sights high.

Over the years I have spent a great deal of time studying the practitioners of our craft, Stanslavski, Brecht et al. I admired how they were trying to just make sense and organise what seemed to be impossible to structure, applying their own focus on the important parts and trying to find the patterns, in an attempt to guide others. I was moved by the works of Charlie Chaplin who soaked up the world around him and let it inspire his art, I was inspired so much I made a pilgrimage to his old studio in LA. I am constantly in awe of any person who fights in any way for the rights of others, as that makes me have hope for humanity. It's a journey from where we are, to where we want to be, everything else is just logistics. If we combine the

scientific approach of practitioners, the passion of Chaplin to be free to express ourselves, and understand that we are fighting for basic human rights, I feel that we can work together to achieve true equality.

We have heard from some of the greatest visionaries currently in our industry in this book. None said it's impossible, it's unachievable, give up, stop trying. Almost all said that it's a team game, and by working together we can achieve true change.

With a realistic and informed approach to disability acting as an art and genre in its own right, we can start to study it, structure it, and teach it. We can soak up this unique world and let it influence our art. As we have established this is a human rights issue and our work and effort can create real social change. If we come closer to employing 44,000 disabled artists, and engage that market of £212 Billion, we can reduce unemployment, boost the UK economy and become a beacon of excellence for the world to follow. I would urge you all in front and behind the camera to not be an audience member in the disability rights movement, be a leading actor, in the blockbuster movie of change, and start to appreciate and enjoy the art of disability.

With thanks...

This is a small book, so I will keep the thanks to a minimum. Firstly, thank you to my beautiful wife Amy, for putting up with my passion for acting and giving me a lovely home to hurry back to, you are my inspiration. Thanks to my parents for the constant and unwavering support of every aspect of my life, and my family and friends for being amazing throughout it all. Love and thanks to my talented friends that have joined me on my journey, Jason Maza, Sam Lyden, Ashley Kumar, and Jack Shalloo, you make this career a pleasure. The tour de force that is Rikki Beadle-Blair, you deserve a knighthood sir, thanks for helping all artists be better. Thanks to Ewan Marshall for launching me into this world of media, and the many lovely chats over the years. Thanks to the wonderful team of Alex Usborne and Justin Edgar you are family to me. Finally, thanks to Paul Viragh, for the hours of reading stuff I send you, the notes and the chats about writing and for being one of the nicest blokes in the film industry.

I would like to thank the following people for taking time to answer questions for this book.

Emma Bloomfield – Agent, Bloomfields – Welch
Julie Fernandez – Actor/Disability Rights Campaigner
Sarah Hughes – Casting Director
Shannon Murray – Actor/Model
Ben Owen-Jones - Actor
Ben Roberts – Director of Film Fund, BFI
Diederick Santer – Joint CEO, Kudos
Martyn Sibley – Entrepreneur/ Founder of Disability Horizons

Paul Viragh – Writer
Paul Wroblewski – Director
Tim Whitby - Director
Ed Vaisey – Minister of State for Culture and the Digital Economy ([1]Please note during the publication of this book Ed Vaisey returned to the backbenches on government, his personal website stating that he will continue to champion the work of the creative sectors)

About me

My name is David and I am a major geek, I have Spina Bifida and use a wheelchair full time. I started acting a decade ago and it's been crazy. I've been dumped, shot by a Nazi, punched, rained on, shouted out, straddled and everything in between. Most will know of my very spiky little character called Adam on *BBC EastEnders*, and I assure you I am almost the opposite of his character, although parts of this book do edge the spiky side. I have also appeared in *Secret Diary of a Call Girl*, *Siblings*, *Best of Men*, and *No Offence* to name a few. I have worked for some of the leading brands in the UK media industry including *BBC*, *ITV*, *Channel 4* and have seen how they work with disabled artists. I have been lucky to work in feature films and travel the world promoting them. I have tread the boards (so to speak), written and produced up to feature film length. I am about to direct for the first time and believe in not limiting ambition in any way. Express yourself always, in all ways.

When I started out acting, I didn't feel like I was representing anyone except myself and my desire to act. A feeling of responsibility crept up on me like a little equality ninja. A few sleepless nights resulted in my understanding that without signing up for it, or agreeing to it I was in a position to either portray disability fairly or in a negative way. I am glad this crept up on me as it has guided me in some key decisions in my career. Having a slightly higher sense of purpose is a great motivational force.

At a decade in the industry it's a good moment to pause and reflect on my work but also disability representation as a whole.

Appendix A

This is a reworked version of the famous Martin Luther King Junior speech. I wrote it for a film pitch and it was my opening statement. I thought it might provide food for thought within the context of this book.

"I have a dream, a dream where all people are represented equally in the media.

I have a dream of a world where your physical ability does not determine where you sit on a bus, which restroom you use, which counter you are served at.

I believe that in this world media is more powerful than politics. It's governs what we wear, what we say, and how we treat each other. I believe segregation is alienation.

We should not be satisfied being told the voice of the many, is more important than the voice of the few. Art is the only act that separates us from animals, it is not the right of any person to oppress the spirit and silence the voice of another, however small that voice may be.

I believe that the need for equality negates the financial needs of the media industry tenfold, and a media industry that fails to represent equally, fails unequivocally.

Life imitates art, and art imitates life. For disabled people this symbiotic cycle is not accessible.

I have a dream where equality isn't a target, it's a reality. I've dedicated 10 years into the pursuit of this dream, and I won't stop until we fully reflect the world we live in.

I have a dream that today is the day that changes the course of disability representation forever. A change that when mirrored in life will lead to a world where disability is expressed and not oppressed.

Freedom is a voice, and it's time to make the world listen."

Appendix B

The following websites and companies have either been mentioned in this book or might be useful for artists looking to research further. This list is accurate as of Summer 2016.

- Spotlight.com
- Castingcallpro.com
- 104films.com
- equity.org
- actorscentre.co.uk
- Bafta.org
- Film London
- Indiegogo
- Kickstarter
- Gogetfunding

"Your life is a three-act story. Fill it with plot, memorable images, and pithy dialogue, and try and make the end have some sort of purpose…"

www.ingramcontent.com/pod-product-compliance
Lightning Source LLC
Chambersburg PA
CBHW060855170526
45158CB00001B/359